here + now

here + now

essays on contemporary art in wales

Iwan Bala

foreword by Mel Gooding

seren

Seren is the book imprint of Poetry Wales Press Ltd
Nolton Street, Bridgend, Wales
www.seren-books.com

Earlier versions of some of these essays appeared in
Planet: The Welsh Internationalist
(www.planetmagazine.org.uk)

Chapter 4 Planet 152
Chapter 8 Planet 143
Chapter 9 Planet 155
Chapter 10 Planet 142
Chapter 11 Planet 145
Chapter 12 Planet 150
Chapter 16 Planet 160

ISBN 1-85411-340-2
A CIP record for this title is available from
the British Library

Seren works with the financial assistance
of the Welsh Books Council

Printed in Plantin by Bell & Bain, Glasgow

Cover image: Iwan Bala 'Calon/Heart' (2003)
Oil and mixed media on canvas 90x120cm

CONTENTS

FOREWORD

This is a remarkable and timely collection of essays. Remarkable for its vitality of expression and the admirably idiosyncratic manner in which it combines comment and analysis, proposition and praise, critique and celebration, argument and irony. Their directness of style is that of a visual artist, and they have a quickness and forcefulness that comes of a passionate belief in the necessity of visual art to the definition of a national culture. Timely in that Wales has arrived at a crucial moment in an epochal process of self-definition, and it is within Wales that it will be resolved in the not-so-distant future. Iwan Bala's voice is his own, but he speaks with a deep consciousness of what it is to be a Welsh artist here and now, and in doing so he speaks for others with a generosity of spirit, a sharp critical insight, and a deep understanding of the place of particular histories within the bigger story of Wales.

The Wales of which I speak is more than a geopolitical entity: it is a complex of living thought and feeling, of myth, history and transmitted custom, of inherited character and trait. Its mental landscapes may be compared to its variegated topographies: they are inscribed with the lineaments of a complicated spirit, shaped by powerful imaginative impulses, shadowed by bitterness. It is not only in its new polity, however significant that may be, or however independent it may one day become, that the identity of Wales will be developed. It is more in the voices of its poets and writers, its artists, composers and performers that the new Wales speaks first to itself and then to the world at large. It is in its arts and learning, its choirs, books, theatres, galleries, its schools, universities and libraries, churches and chapels, its pubs and its playing fields that its distinctiveness is to be savoured. And of course, this new Wales is, in many aspects central to its character,

already there, shaped and refined by the generations of those who felt themselves to be distinctive, felt themselves to be Welsh, at times when such an identification was perceived as of little significance in the wider world, and when its own particular linguistic heritage was derided and suppressed.

Unpredictable and imponderable movements and events, some within Wales and the United Kingdom, others in the world beyond Cardiff and Westminster, are irresistibly creating the conditions out of which a new sense of national identity will grow. Heterogenous elements, political and constitutional, economic and social, institutional, cultural and linguistic are coming into new kinds of dynamic creative and critical relations to each other: the new century coincides with a new era. The richness and power of Welsh culture, and its distinction and uniqueness, will depend upon its accommodation of an historical diversity, of language, of politics, religion and racial inheritance, and on its renewed acknowledgement of the living significance of what David Jones called "the things of Wales", things which should be the proper concern of all who claim a regard for the foundational things of this island. (As an Englishman who loves Wales – not uncritically – I may claim such a concern as a justification to write this Foreword.)

Against that definition of a distinctive national identity, in all its aspects, are ranged powerful forces, and an apparently ineluctable impetus to homogeneity and cultural sameness. In deepest Wales the high street and the shopping malls are indistinguishable from those in any other part of the Island of Britain. Artists from Wales, as from elsewhere, have historically migrated to the centres of metropolitan and cosmopolitan culture, actively sought the conditions of homelessness and exile that was the lot, sometimes sought, sometimes imposed, of those heroic high modernists who valued personal and artistic freedom, and who in their work sought the abstract qualities of a free-standing objectivity and universality. There are those who today think of Hoxton and Hackney, as in the 80s they might have thought of the historically displaced West Berlin, as the no-place where differences don't

matter, and where bright ideas, money and celebrity are interna-
tional currencies. But the days of the avant-garde are gone; things
fall apart; a no-place is the centre that cannot hold.

It is as well to remember that we have been here, in some
respects, before. (I know that we cannot step twice into the same
Heraclitean river.) David Jones, who meditated as deeply as
anyone on the problems of personal-artistic displacement in
Welsh culture wrote this in 1944, in the midst of the world war:

> It is then against the background of a global machine culture that
> any contemporary or future feeling for [the plastic forms of a
> visual culture] must be seen. It is against this background that
> any individual, or other than individual, feeling left over from the
> cultural locality-feelings, must now express itself. In the case of
> Wales we have a locality within a locality within a locality – i.e.
> Wales, Britain, Europe. [We can extend this now to the globalised
> world.] We have suggested the ironing-out process (especially as
> to the making of things) that is overtaking the larger traditions
> and the greater localities. It is clear that the smaller ones are
> subject to the same problems – one would suppose, all things
> being equal, to a greater degree. Be that as it may, any
> 'Welshness' expressed in plastic form of any description whatso-
> ever has now and will have in the future... to maintain itself
> against this megalopolitan background and will have to resolve
> the same extremely difficult problems which confront the 'arts'
> all over the world.

It is those "extremely difficult problems" that preoccupy Bala,
and which he addresses as an artist of visual forms, as a writer,
and as an activist. We live in a time when the distinctiveness of the
'locality' (both large and small) is under threat, and when the
artist is being increasingly deracinated. We are witness now to the
extinction of those cultures which do not meet the economic and
political requirements of the dominant economic *imperium*
(which is not that of one all-powerful nation state only but of an
international class whose interests it serves) and to their deliber-
ate exclusion from History, 'the end' of which we are witnessing
in many places in the world, and with it the memories and

dreams that have created the human and given it "a local habitation and a name". (Against such destruction the 'provincial' is quite safe, being always in favour with those who hold power at the centre against which it defines its subordination.) Bala's concerns with the *locality* of Wales, a *locus* historical, cultural and topographical, are exemplary and salutary. They are concerns that will come to be seen as central to a new kind of philosophical and artistic modernism, an inter-national spirit that rejoices in diversity and is grounded in optimism and hope, and which stands up to the culture of the megalopolis.

INTRODUCTION: WALES-ART-WORLD

As the twentieth century progressed we have been forced to become more flexible in our understanding of what art is, less prescriptive about its role. The essays in this collection chart some of the trends taking place in what I call 'Wales-Art-World', in this first decade of a new millennium. The term serves to describe a community of artists, a network of galleries, critical discourse and the cultural context that exists in Wales at present. It may also suggest that Wales, through Art can become part of the World at large.

What, who and where are we? If art is a key to unlocking the psychology of a nation at any given time, what, if anything, does our practice here + now show us? This collection of essays might throw some light on these questions. They were written over the past three years, several appear here for the first time and some are modified versions of essays which have appeared in the magazine *Planet*, others are based on lectures given at the University of Glamorgan, Swansea Institute, Gregynog and The National Museum and Gallery of Wales. The title of the book was partly inspired by an exhibition of young Basque artists at the Museo de Bellas Artes in Bilbao in 2002, called in Basque *Gaur, Emen, Orain* (Today, Here, Now). The exhibition title was chosen deliberately to emphasise the very contemporary nature of the work shown, but also to invoke the memory of three radical artists' groups in the Basque country in the 1960s, bearing those names. The guiding light of those groups was the great sculptor and essayist Jorge Oteiza, whose death at the age of ninety-seven was reported as I write this, in April 2003. In 1963 Oteiza published a seminal literary work *Quousque tandem…!* ('Is this where we have reached?'). The book was subtitled 'An Effort to Interpret

the Basque Soul'. I make no comparable claims for this book, though I do applaud the awareness of a 'continuing presence' in the contemporary art practice of the Basques, which I refer to here in a Welsh context.

But as the title also suggests, a great deal of the art produced today exists solely in the 'here + now'. This reflects the growing tendency to see art as a non-permanent stimulant, unlike the 'built to last' monuments of a more certain age where values were held to be universal and timeless. Above and beyond all that, the title makes the simple statement, 'we are here, this is now'.

However, it is obvious that the 'here' has implications on the 'now'. History and place has influence on present art practice, and more importantly, on the apparatus of the wider 'art world'. 'Wales-Art-World', though striving to emulate the 'London Art World' a lot of the time, is nonetheless completely unique and has unfortunate as well as positive aspects. I make an effort to highlight the positive, but cannot avoid taking issue with some of the negatives. These essays are underpinned by an awareness of post-colonial thinking and the question of whether such a viewpoint can be used to predicate new assumptions for Wales in the twenty-first century, whether such a condition is revealed in its visual art and further to that, whether there is an endemic malaise, an element of 'culture shame' that inhibits the proper promotion of our art and artists? The first section of *here + now* contains essays and lectures that consider this theme.

The second section is a collection of essays on individual artists. I had no thematic overview or 'agenda' in mind other than to offer some insight into the work and context of these artists, to examine certain clichés such as art as catharsis and art and politics, and to look towards new media, installation, lens-based art and performance. It was only on re-reading them that I realised that 'painting', far from being deeply buried, was near the surface, even when discussing artists who are not known specifically as 'painters'. This highlights the fact that despite the tendency in the public galleries to sideline the practice of painting, it proves to be an abiding philosophical and procedural

foundation in the production of art here + now.

The three closing essays fall into two parts; each begins with a thesis of sorts and follows with examples of current projects that are instances of the ways forward being sought by artists in Wales through their practice at the moment. The first essay looks at public art that challenges traditional expectations; the second features a gallery in Cardiff that promotes emerging and established artists in a confident and 'hybrid' manner. The third deals in a hypothetical way with our internalised mindset and makes a brief analysis of the work of an artist who questions and reveals the inner workings of that mindset.

Here + now is an exciting time: Wales makes its first appearance at the Venice Biennale; a new and innovative art prize, Artes Mundi, is launched; a determined drive is finally underway to establish a National Gallery adjacent to our National Museum. There are a host of initiatives arising from Cardiff's bid for European Capital of Culture 2008, which may well secure us a much needed large contemporary exhibition space in Cardiff. Aberystwyth has a new and wonderful Arts Centre and Oriel Davies (known previously as Oriel 31) is vastly refurbished. Oriel Mostyn has plans to enlarge a space that has been at the forefront of exhibiting and awareness raising. Bute Street Artists' Studios, at which I am fortunate to have my studio, will soon have an operational gallery. Construction is about to begin on a new arts centre in Caernarfon. We maintain and improve a network of galleries across Wales that many a nation materially much wealthier lacks. Cywaith Cymru . Artworks Wales is engaged in an ongoing national project of public art, both commissions and residencies. Eleven artists are currently working on site at Middleton, the National Botanic Garden of Wales. Over the past five years, five artists have spent time living and making work on and for Bardsey Island, Ynys Enlli. The National Eisteddfod visual arts pavilion is becoming more and more a true reflection of professional art practice in Wales. This is a time for jubilation.

Why then do I still feel that we are held back by a lack of confidence in ourselves, in our own self worth? I am not alone in

believing that the reason lies in the historic legacy of Wales, and in the subsumed effects of colonisation. We do ourselves no favours when we deny that this is so. Art is a tool by which we can prise ingrained tendencies to the surface, expose them, and leave them out to dry. In the shaping of a new, confident Wales, art has to be given the space and the platform to address its public, to encourage debate and dissent as well as beauty and appreciation. I am not talking only of art that deals with these 'issues' as subject matter, but of all art. Art is a human product of a particular place and time, in all its contradictions, and is one of the few products not governed totally by supply and demand, therefore at its best it is free to express opinions, to be revealing, to act as the subconscious of society. Artistic production is always, in that sense, site specific and culturally attached, even when it attempts to be a denial of that concept. Curators, funding bodies and administrators need to be proactive in promoting our own and not blindly repeating the programmes and agendas of curators elsewhere. The essay 'What to show? Who to show? Where to show?' raises some of these curatorial issues, in particular pertaining to the 'Wales' representation at the Venice Biennale in 2003.

In putting together this collection of essays about contemporary art in Wales, I am aware of how little I can include and how much remains to be addressed. One day spent looking around the galleries of north Wales, or one day looking around the galleries in Cardiff, results in an amazing list of diverse and exiting things to see that is comparable to a large metropolis anywhere in the world. Shani Rhys James contrasting with Mariella Neudecker or Tim Davies in Wrexham, David Garner in Aberystwyth. I could go on, Ffotogallery, André Stitt's Trace performance space, g39, The Queens Hall, Narberth, Ruthin Craft Centre, Llantarnam Grange, The Museum of Modern Art at Y Tabernacl in Machynlleth, the Harlech Biennale amongst others.

The new building in Caernarfon mentioned earlier, designed by Richard Murphy, the architect of Dundee Contemporary Arts and the Fruitmarket Gallery in Edinburgh, has one telling architectural detail from which it is possible to extract a symbolic

trope. A mirror strategically positioned outside a large window, reflects a view of the Menai straits and Ynys Mon, refracting it into the viewers' eye-line as they sit in the theatre. It seems to me that this is the very thing that Art does, it brings into our experience, our line of vision, something that has always been there, but that cannot always be seen because of our atrophied position. Something that is ever-changing like water, that promises new vistas, giving us a sense of metaphysical movement and transformation even whilst we ourselves, physically, remain rooted.

We no longer need to view ourselves as provincial in any sense, and we should now be launching ourselves outwards, not just celebrating those artists from Wales who have made their reputations outside Wales, both now and in the past, but promoting the vibrant art that is produced here + now.

<div align="right">Iwan Bala, 1st July 2003</div>

1.1
WHO NEEDS ARTISTS?

It doesn't need pointing out that artists are individuals, more so than in most professions perhaps, since their work depends on this individuality. Artists are encouraged to 'think differently'. It should come as no surprise then to find that they often think differently to each other on almost every topic. Organizing artists into groups or unions has always been difficult, and when achieved, such groups tend to be short-lived, riven with divisions, or maintained solely through the dedication and goodwill of a few members. Artists resist the herding instinct.

One thing on which all artists will agree however is that they need time and space to make art, and they would like to be 'sponsored' in one way or another to do that. This 'sponsorship' has been viewed as a requirement in an enlightened, civilized culture, which rewards the artist for fulfilling an important, some might argue, crucial function within society. Such support, ultimately, should come from the State. Art, according to this theory, cannot be at the mercy of market forces: commercialisation leads to vulgarisation or a dilution, 'dumbing down' in other words, removing Art from that realm where it attains (or is perceived to have) an almost spiritual or mystical function within a primarily secular society.

Why should society feel honour-bound to support artists who make no effort to make saleable work, and how does Art benefit society ... what does Art do?

> The creative process, so far as we are able to follow it at all, consists of the unconscious activation of an archetypal image, and in elaborating and shaping this image into a finished work. By giving it shape, the artist translates it into the language of the present, and so makes it possible for us to find our way back to the deepest springs of life. Therein lies the social significance of art: it is constantly educating the spirit of the age, conjuring up

the forms in which the age is most lacking. The unsatisfied yearning of the artist reaches back to the primordial image in the unconscious, which is best fitted to compensate for the inadequacy and one-sidedness of the present.[1]

Rather than merely reflecting the age in which it is made (as much of today's art seems to), Jung is suggesting that art should offer more. In an age of instant gratification, it offers pause, reflection. Art is not 'entertainment', though it is assumed to be; I don't like its coupling with Sport as in ministries for the arts and sport. At its best and given due attention, it provides psychological sustenance and solace. To know that fellow human beings can make things that are outside the realm of base human needs, that are made to 'grace' all our lives, is in itself a revelatory and life-affirming experience. This is where we get to the 'spiritual' aspect, for lack of a better word, since art operates on a psychological level akin to faith and religion. Dylan Thomas in the 'Note' written as preface to his *Collected Poems* in November 1952, hints at this:

> I read somewhere of a shepherd who, when asked why he made, from within fairy rings, ritual observances to the moon to protect his flocks, replied: "I'd be a damn' fool if I didn't!". These poems, with all their crudities, doubts and confusions, are written for the love of Man and in praise of God, and I'd be a damn' fool if they weren't.[2]

In this analogy, the poet (artist) might be seen as the shepherd of men, who protects his flock by the use of his "craft or sullen art". The same sentiment is found in this quote from the Cuban artist Raquelin Mendieta: "Art and Spirituality are one and the same, works of Art are prayers on the altar of life."

There is evidence if you read most artists' biographies or statements to suggest that this idea is deeply held and shared. The painter Alan Davie, for example, says:

> In painting as in alchemy, one is involved in a magical transmutation of matter into an indefinable spiritual essence, and like the alchemists, I have in the end reached some enlightenment in the

realisation that my work entails a kind of symbolic self-involve-
ment in the very process of life itself. And when the magic
happens, the base materials have become pure gold.[3]

If your particular frame of mind finds this idea too fanciful,
remove art completely from its priestly or shamanistic role in
Society and it may, alternatively, be seen to be a political instru-
ment of dynamic potential. Art can be harnessed to political ends;
it can spearhead regeneration, re-invention, re-imaging, cases in
point being Bilbao or Newcastle-Gateshead. Art offers subtle
unifying elements to a multi-cultural view of contemporary
society. That Art can be beneficially harnessed to the aims of
politicians cannot be denied, but (and perhaps this has been
played down in recent conformist times) Art can also work as a
revolutionary apparatus, something that also scares politicians.
Raymond Williams proposed a model that divided human culture
into dominant, residual and emergent domains. The dominant
maintains its hegemony by the use of a 'selective tradition':

> in any society, in any particular period, there is a central system of
> practices, meanings and values, which we can properly call dom-
> inant and effective. This implies no presumption about its value.
> It is this central system that formulates the selective tradition; that
> which, within the terms of an effective dominant culture, is always
> passed off as 'the tradition', 'the significant past'.[4]

In opposition to this 'selective tradition' there is a 'residual
culture' which is reactionary and an 'emergent culture' which is
revolutionary.

In these cases, an avant garde in art is an 'emergent' and cultur-
ally revolutionary force of revitalization; it offers an alternative
'tradition' in the face of moribund and lethargic monumental
systems. It is commonly believed that an avant garde no longer
exists. However, if we look at art that challenges accepted notions,
questions the state or the market or prejudice, racism and imperial-
ism, there lies the avant garde. Only people who equate New York's
SoHo, or Hoxton, with artistic production in general, can blithely
assert that the avant garde is dead. This has also been seen as the

act of 'compensating the canon', that is, challenging and offering alternative variants to the accepted and 'selective tradition'.

Historically, the fact that art has the power to question the 'selective tradition' makes its funding by the perpetrators of that 'tradition', or those with a vested interest in its perpetuation, problematic. Art's beneficial effects, characterized as "a society in conversation with itself" indicates however that a truly confident and mature culture should embrace the transgressive elements of art as much as the confirmatory, both are life affirming.

A third option (and these options are not mutually exclusive) is the idea of art as a provider of 'completeness', a role closer to that of the spiritual/mystical, but one that is more or less empirical; if aesthetic and formal aspects can be empirically quantified.

Writer Jeanette Winterson in notes for a theatrical show of *The Power Book* says:

> It is very difficult for us to look at things. Life passes in a blur. We don't know how to see the object itself as it really is, because our own subjective reality is always intruding, and we are not in command of ourselves enough, to know how subject and object are always coming together and forming new wholes. Our experience is fragmented and partial.
>
> Art brings together our disparate realities and gives us a coherent experience. The emotional satisfaction of art is the satisfaction of wholeness.[5]

As the New York critic, Robert C. Morgan says:

> The challenge is how to rediscover the act of seeing in this desperate age of speed and information, how to slow down and regain consciousness, and how to enter the world once again with an open mind and a new vision of what the future may hold with the prospect that it may benefit our lives.[6]

To return to the viewpoint of the artist at its most simple level, let me finish with the words of Mexican artist Francisco Toledo:

> I do what I do without any hope of a lasting or significant effect. I do these things because I feel it's my duty and because I have the means to do them at this moment in time.[7]

Tim Davies 'Capel Celyn' (1997) mixed media installation, dimensions variable

1.2
RE-INVENTING RE-INVENTION

Delivered to the Association for the Study of Welsh Writing in English, Gregynog 2002.

When I first gave a title to this paper, sometime back in the last century, I had no idea how apposite it would be. I had practically completed a paper for this conference, initially scheduled for 2001, but in the intervening year, that paper has vanished from my computer. I had no backup copy, and could find no trace of the handwritten notes I made in preparation for it. This essay is therefore a re-invention of my mostly forgotten first invention. Then, lo and behold it was rediscovered and I had to graft parts of the old back into the new. This is quite a preamble, but it serves to illustrate the nature of re-invention, and it provides me with a good beginning. Re-invention is as often accidental as deliberate, bogus more often than truthful. Since this paper has been scheduled at the end of a busy day, just before poems and pints, I take it that a heavy academic treatise is not required. Just as well: as an artist, I am an inventor of sorts, in my mind a re-inventor even.

The oft-quoted words of Gwyn Alf Williams, "Wales has a history of rupture and re-invention" or "the Welsh make and remake Wales ... if they want to" have become lynchpins for my thinking about my work since the early 1990s when I was forced, by the circumstances of an MA course to validate it in a more theoretical language. I passed over Foucault, Derrida and Lacan to plump for Welsh theorists, taking great succour from Raymond Williams and also Emyr Humphreys' *The Taliesin Tradition*. This was not a display of partisanship, but simply that I found them of more relevance to my own work, and crucially, I found them easier to read. They led me in turn to the writing of Edward Said, Thomas McEvilley, Octavio Paz, Franz Fanon, Gerardo Mosquera and other writers of postcolonial critique. My

thesis was written on the subject of 're-invention' in the guise of 'shape-shifting'. I collaborated on several occasions in the early 90s with the playwright Ed Thomas, whose mantra was 're-invention'. Looking back, I think it was a case of being inventive in a new way as much as re-inventing, certainly with the plays *House of America* and *Flowers of the Dead Red Sea*, and the intoxicating excitement of seeing ideas first talked about in the pub, being turned into full-blooded reality on stage was a great experience. However, I sometimes wonder whether the term re-invention has not already become over-used and romantically attached to a *zeitgeist*. It has certainly become a 'key word' in the cultural marketplace, and over use can lead to loss of meaning. Pop stars and politicians re-invent themselves. Postmodernism is fuelled by re-invention. In much the same way as sex and entertainment has to be re-invented by each generation, is it not the same for nations?

To re-invent is to replace something that was there before with a more useful version, (or to use contemporary parlance, a sexier version). This means that the existing object was itself an invention in the first place (even a re-invention). Icons of identity are such inventions; they are created at particular times and for particular purposes. In a colonial situation, they are sometimes invented by the indigenous population (Iolo Morganwg's Gorsedd of Bards), but often by the colonizers, or from the perspective of the ruling hierarchy, (Lady Llanover and the Welsh costume). Re-inventing the latter becomes a prerequisite condition of the postcolonial period, re-inventing the former a function of pragmatic nation building. I leave the discussion on postcolonialism and Wales to another paper, but it remains true that Wales is undergoing a change in its aspirations and view of itself in the world, and that this has led to a process of re-invention that can be examined through the prism of the visual arts of Wales.

Since the 1980s, the theme of identity has become a prime issue for art theory and practice. Identity is a key word in critical theory and debate, but is frequently used quite negatively and without much debate. Whilst for our near neighbours the issue of Welsh identity still proves problematic, it is also problematic

within Wales itself, and it is here that some assumptions are being made about the nature of the proposal in the book *Certain Welsh Artists*[1] which I compiled in 1999. Re-invention is a postcolonial strategy that I have witnessed in the new art from Zimbabwe, Cuba, Ireland and elsewhere, but is also a feature of feminist art, black art, gay art and so on. Such communities needed to re-invent themselves as independent identities in a global context. This is often tied up with a rejection of some of Modernism's prevailing attitudes, which in this case is seen to be the received orthodoxy of imperialism; a western, hegemonic, utopian univer-salism imposed by the male hierarchies of the dominant powers. *Certain Welsh Artists* is a necessary book because it deals with these issues as they manifest themselves in the context of Wales and its artists.

The process of the recent re-invention, of re-imaging Wales in visual art, begins with the work of Paul Davies and the Beca Group in the 1970s and 80s. Beca's importance is still largely unrecognized. It was the instigating force in the politicisation of Welsh art, and one that focused international trends and method-ologies into a language that highlighted specific concerns in Wales. Beca artists' drew from sources as diverse as Arte Povera, Fluxus and, particularly in the case of Ivor Davies, Surrealism, the Paris avant-garde and Destruction in Art. Beca made collab-orative pieces and staged events as well as making individual works that dealt with such issues as holiday homes, Tryweryn (a modern site of national, collective memory and trauma), and loss of language – re-inventing, or appropriating elements like the love spoon and the map of Wales for the purposes of a commen-tary of protest. There were embryonic attempts at a sort of agit-prop art, mail art was made, pieces of art being posted back and forth between members to be added to individually, the artwork thus collecting a history as it travelled.

A recent manifestation of this kind of work, but drawing its methods from new sources, is Tim Davies' installation floor piece of 1997, 'Capel Celyn'. Utilizing a single five-inch nail found in the dried up reservoir, replicating it 5,000 times in wax and laying

these as a ghostly carpet on the gallery floor, Tim Davies creates a mute reminder of the silence of the lake, the silence of a community and perhaps, nails in the coffin of a particular Welsh identity.

Many artists in Wales have taken up the particular burden of carrying a dissenting voice that is nonetheless 'true' to present day Wales. David Garner for example, with his vast tarpaulin-like canvases and installations chronicling the decimation of the coal industry and its attendant ways of life and values in the mining communities of south Wales. These are not the romantic views of miners seen in the canvasses of Josef Herman or Valerie Ganz, though there is a heroic element to the work. Collectors looking for Welsh art at Sotheby's and Phillips auctions might disagree, but depictions of miners have been relegated to the Wales-as-was department, along with the Welsh tea party and soon enough, flat capped farmers with sheep dogs.

The need for re-invention is always there. The tradition of landscape painting, the most identifiable visual art form from and about Wales in the minds of the majority of the population as well as the world outside, like male voice choirs, is pleasing, reassuring and very marketable, but needs constant re-inventing if it is to have any worth as art, not commodity. The paintings of Kyffin Williams are undoubtedly the equivalent of male voice choirs; skillfully put together, they are inspirational, iconic, and accepted as such in Wales and outside, but as landscape paintings, as art, they have been stuck in the same groove since 1950.

Peter Prendergast and David Tress are engaged in the painterly re-invention of landscape painting, making up new words for the old visual language. Catrin Webster, Brendan Burns, Geoffrey Olsen, are all painters who take a new angle on the Welsh topography as does Mary Lloyd Jones who chronicles today's landscape as a palimpsest of half-forgotten yesterdays, buried sometimes deep and sometimes close to the surface. Incorporating poetry, she invests her paintings with that essence of 'deep memory' that only poetry passes down to us. Kevin Sinnot and Shani Rhys James invent new interpretations of the figure within that landscape. Osi Rhys Osmond paints the landscape of Wales in the

light of industrial decline and the grassing over of memories, a state of "cultural Alzheimer's" as he calls it. The younger Angharad Pearce Jones makes a similar statement in a recent piece of work. Having practiced as a blacksmith artist she has now 'nickel plated' her own anvil, rendering it beautiful but useless as a tool. Her installation incorporating the anvil presents it as an ornament of the heritage industry, all that is left to remind us of the heavy industry culture of Wales.

The photographs of Peter Finnemore, from his familial garden of Gwendraeth House in Pontiets near Llanelli, re-invent the typical Welsh family as a quixotic and vaguely exotic phenomenon. He comments ironically on Welsh history as it was taught in 'Lesson 56 Wales' (1998), presenting photographs of his grandmother's school history textbook. I quote: "When speaking of England it is understood that Wales is also meant" bringing to mind the famous *Oxford Encyclopedia* statement, "for Wales, see England". Lois Williams makes her work out of the detritus of the farming way of life, through the methods of traditional women's work, a work like 'The Simplest Aid to looking at Wales' resembles the learning blocks of an alphabet, a Welsh language alphabet.

We are faced with what appear to be diametrically opposing tendencies in art. The first is the postcolonial, site specific, culturally specific art that I have called 'custodial aesthetics'. This, I suggest is art that carries with it a memory or an idea of a specific culture and its place in the world, and that whilst its specificity does not limit its appeal, it stands in opposition to the art that moves towards a 'new internationalism' which is stylistically homogenized and devoid of content. Metropolitan theorists, as they invariably are, are quick to point out that 'identities', like religions, are fabricated, invented and imagined to give us comfort and solace. In a world that appears to be fragmenting – "the centre cannot hold" to paraphrase Yeats – it feels good to be part of a gang, 'our gang'. Naming your gang, your imagined community, is important because we perceive the act of naming to be akin to understanding and being in control. By naming it we fix it. We extol a fabricated cultural homogeneity because we fear

the tower of Babel that the world has become.

This lecture presents only a selective view of contemporary art in Wales. For a truly re-invented Wales, we have to ensure that we are not imposing our own "selective history" in Raymond Williams' words, to our detriment. Wales is not one narrative. Can we make the new national story that we tell as inclusive as is possible?

The mantra "re-invent, re-invent" sometimes sounds desperate, particularly in the context of a concept such as 'Wales', but, like postmodernism, it is not something we choose, but something we live within. It is of this time. In as much as the essentialist credo of modernism, its belief in the primacy of form over content, has become increasingly discredited, so outmoded visions of Wales need re-inventing, and the role of the visual artist is clear in this process. Transitional times need recording and new images need to assert themselves. The greatest re-invention in Wales' visual arts is the very fact that many more Welsh men and women are making art, and that many more artists of all nationalities are choosing Wales as a base to work from. This means that artists are able to stay in Wales to work in a way that was never possible before, and that they do not feel themselves to be provincial when they do so. What is required is for our institutions and curators to have a similar self-confidence, so that this re-invention becomes a visible phenomenon, and art in and from Wales can be promoted.

In a paper given at a conference by the Institute of International Visual Arts called 'Global Visions', Gilane Tawadros dismantles the construct of cultural homogeneity and concedes that:

> the forces of nationalism and internationalism have been powerful catalysts of change and regeneration in our past century, but only when they grow out of present realities and not abstract concepts floating somewhere high up in the stratosphere, far removed from lived experience.[2]

The work of artists in Wales today proves that Wales' present realities can still be harnessed for change and regeneration, or, to come back to the title of this paper, re-invention.

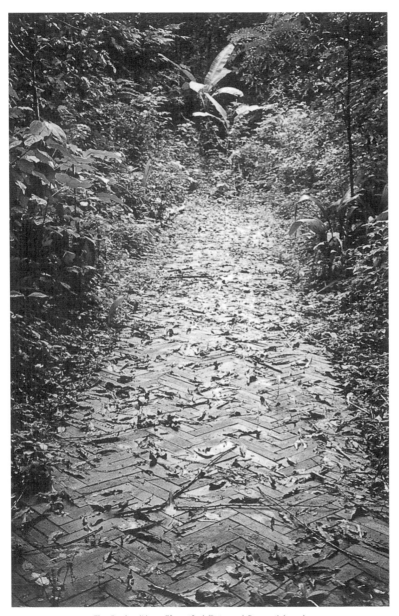

Tim Davies 'Llawr Fforestfach/Returned Parquet' (1999)

1.3
DEEP MEMORY, SHALLOW MEMORY: THE LANDSCAPE

In his book *Landscape and Memory*[1], the historian Simon Schama explores the relationship between human society and the landscape. 'Landscape' includes not only the physical landscape, but also the psychological and cultural terrain. A psychological map of the mind of a people who live in certain places appears like a transfer on the topography of their ancestral lands. Or, universal motifs and symbols, unbeknown to us, draw us into ancient metatextual meanings. Art which uses the landscape as inspiration and source material taps into meanings that are concealed and stored in archetypes. Often, subconscious relationships occur involving memory with landscape, generating a resonance within the onlooker's mind, and making the work of art into the location of memory.

Schama explains how, for example, the forest is synonymous with northern European, Germanic and Slav culture. Even today, German towns have a protected area of forest that citizens can use for picnics and for escape. The forest came to symbolize refuge and 'ancient homeland'. This attraction has been well served by artists like Caspar David Friedrich and lately Anselm Kiefer whose monolithic works are an ironic commentary, postwar, of Germanic myth and pomp. They are also seen by some as contemporary propagations of those myths. Schama also refers to the anthropomorphic use of landscape, fountains and rivers as the 'source of life', witnessed in Courbet's 'The Origin of the World' of 1866. These artists draw on a memory located in the deep time of human society, a time before writing, before urbanization, a period that persists because it left a permanent memory in the minds of human beings generations apart, who now live far from their roots. To describe this phenomenon we might usefully borrow the terminology of geology.

'Deep time' and 'shallow time' are terms used to describe the

geological history of the planet. Similarly, human history, historic memory, is split between the deep and shallow. Landscape and the response to it through the filter of memory and consciousness is the place that for many, these deep and shallow memories reside. Memory is of paramount importance in any attempt to define and redefine an identity, whether a dominant one, or more crucially an identity which has been suppressed by another. In a process of 'decolonisation' indigenous modes of memory must replace the 'colonised' modes, if, that is, that memory still exists. Sometimes memories are confused, hybrids of both recent and past. For many cultures, the landscape of a 'homeland' often holds the key to reawaken memory, and this is particularly true in Wales, where as the writer Emyr Humphreys says, the landscape

> immortalizes experience, so as the stream of life flows on, and we are carried with it, the residue that it leaves in landscape is myth. This is what human beings of the past left behind them; and what they left behind them is now part of our present. So it's a deposit, a raw material in the literal sense. Just as you dig down for gold, coal, you dig down for myth as well. It is a raw material vital for your well-being.[2]

However, until recently, the Welsh landscape was mainly a Romantic ideal, painted for tourists by touring artists like Turner, Sisley, Sutherland, John Piper and Paul Nash, and honoured though we must feel by their attentions, there was most definitely a colonisation of Welsh landscape through art. Paint it, tame it, own it. And much of it was owned by the English or by an Anglicized landed gentry. Romantic artists, like Romantic poets

> perfectly exemplify the colonial mentality. They come to a place and fail to see the culture because they see the landscape only as a natural resource of which they're free to make whatever they like.[3]

Emyr Humphreys sought to redress the balance in his collection of poetry, *Landscapes* which is

> intended for, or addressed to, a colonized people who have been deprived of the ability to see how the record of their pre-colonial history lies all around them in the now mute language of the landscape.[4]

In what could be called a homology, many visual artists have also been slowly reclaiming that landscape. Apart from the linkage with pseudo-Celticism that was fashionable in England at one time, and the hijacking of the Ancient Britons to sanction the English dominance of the world stage, it was not until the paintings of David Jones that history and myth show up in visual art, inspired by poets. David Jones of course, was both artist and poet remembrancer, who delved deeply into the 'Matter of Britain' as revealed in myths, Roman histories, early Welsh poetry and writings of clerics like Gildas and Giraldus Cambrensis (Gerallt Gymro).

We know that landscape painting has been synonymous with Wales for a long time, be it a Romantic view of artists who, in their search for the sublime, wanted to 'discover' an Alpine landscape closer to home, or as, later, the industrial landscape of the south Wales valleys became a popular genre. In the works of many such industrial artists there was a sense of the 'picturesque' transferred from unspoiled 'heavenly' landscape to 'infernal'; from paradise to paradise lost. What becomes apparent to us now when looking at these scenes of industry is the swiftness of its passing. But this was still deeply related to a sense of being a view of another place, of being not English landscape.

If we were to create a contemporary canon of artists from Wales, (whether it is necessary to do so or not is a moot point, and who has the license to do it?), how many of those artists would still today maintain a deep involvement with landscape, with specific place? Artists like Ernest Zobole, whose world became no larger than the view from the window of his home in the Valleys of south Wales. How he painted and repainted that view over the years and captured the human condition and the whole universe in its narrow vistas. Peter Prendergast and Mary Lloyd Jones: their very decision to remain in Wales and within their particular square mile to work shows their attachment to a sense of place, or John Knapp Fisher and others who selected a particular landscape in Wales to live and work in. Landscape rendered as relief maps of Wales by Paul Davies reflect similar works by artists in Latin America, who have often used outlines of

demarcation to comment upon the possession of territory and the dispossession of the native soul. There is a great tradition in Latin American art, of repossessing the landscape through challenging European modes of depiction. José Gamarra for instance, paints scenes that could come from nineteenth-century views of the jungle, which he then populates with anachronistic historical and fictional figures.

Even when we look at artists who are not ostensibly dealing with the topographic, 'place' and its history of events remains a touchstone to an understanding of their work. I am thinking of the paintings of Brendan Burns, the installation pieces of Tim Davies, David Garner and Lois Williams. Tim Davies' work, I have argued elsewhere, transcends both his formal constraints and subject matter to become 'equivalents' of a wider phenomenology. They replicate the Welsh condition by being like an iceberg, only a small percentage of which is visible on the surface, the rest submerged. Unless you have prior knowledge of what lies beneath, you will miss it completely, and be satisfied with the beauty of what you see on the surface. One is tempted to take this simile further, but I suggest that it might be foolish to do so. For me, the resonance of his work is achieved by the very lack of obviousness, of direct illustration. Though they are sparked off by events in recent history – in shallow memory – such as Capel Celyn or the closure of the coal mines, the form that the work takes allows a reading which connects us to deep memory, whilst the work of David Garner remains firmly connected to the recent events of history, in our shallow yet quickly fading memory.

It can be no coincidence that the Welsh themselves began to associate landscape painting as being in some way an authentic vision of Wales, hence today, the overwhelming popularity of the iconography of Kyffin Williams above and beyond any other one artist from Wales... no Welsh home should be without one. His exhibitions become a scrum of frantic buyers, who, in desperation, will purchase work they cannot see on the walls because of the crush of the crowd. It isn't the exact picture that matters, what matters is owning 'a Kyffin'. People don't need to see what they are

buying because they know (in their heart of hearts) what these paintings, prints or drawings represent: they are icons. This phenomenon of Welsh visual culture warrants some analysis... There is a bardic quality to the persona of Williams, which is manifest in the way he is known simply by his first name, which operates like the 'bardic name' adopted by poets such as Cynan. His version of the Welsh landscape is coloured by that same romance, either in the darkly looming peaks of Eryri, or of sunsets over the coast of Lleyn. The stooped solitary figures of farmers with their dogs on the slopes of the hills, all done with thick palette-knifed expressionism are timeless, or rather they are located in a comfortable past outside of time. It is a version of that colonialist view of Wales adapted for a home audience, unsullied by pylons, tractors, wind farms, caravan sites, or even the dark and silent plantations of the Forestry Commission. This version of Wales, obviously touches some deep vein of recognition in its many admirers, it has resonance for them. They evoke the durability, solidity and mass that the Welsh, in particular the Welsh-speaking Welsh, in some recess of 'deep memory', associate with the fastness of their mountain strongholds of Gwynedd, and that fastness in turn symbolizes the long resistance and survival of the venerable language.

The physicality of Williams' painting technique, at its best, brings the landscape almost physically into the room. The paintings become objects that are materially heavy and brooding, rather than mere 'views through a window'. It is not the landscape of rolling hills, feminine outlines, the motherly *mwynder* of Maldwyn that he paints, but the looming mountains of Snowdonia which he can view from his home on the flat Ynys Môn. Its quintessential appeal is to the dark, dramatically romantic disposition ostensibly located within the Celtic genes. Thomas Jones' 'The Bard' of 1774 had the same distillation of doom-laden, elegiac redemption that proves attractive both to the Welsh predilection (perhaps an unavoidable and necessary adoption) for noble victimhood, and to the English preferences for exoticizing the 'other'. For them, the landscapes are continuations of that Romantic (and essentially Colonialist) tradition that

depicted Wales and its otherness, its exoticized and exaggerated difference. To the Welsh that buy the work, they operate as semi-religious icons of identity. These icons of the timeless mountains, access a 'deep memory' through the act of painting in shallow time, and become near-mystical objects in their own right.

The 'historic associations' are not alluded to directly in Williams' work, but the painter Mary Lloyd Jones, an artist far more politicized in her engagement (it might be argued that she comes of a different generation, one which is much more aware of cultural politics, of feminism and postcolonialism) with the landscape of her native Ceredigion makes it impossible for us not to be aware of the 'deep memory' invested in location, the archaeological and poetic aspects contained and evoked by certain places. Mary Lloyd Jones is also a popular artist with the Welsh audience, in particular those who can read the allusions and are cognisant with the quotations and references in her work. One can find here the feminine qualities of the landscape largely absent in Kyffin's work, not only because the landscape she paints is less rugged and thrustingly jagged, but that she brings to her work the sensibility of a female awareness, even overtones of traditional female creativity; quilting, embroidery and weaving. Thus, she records, not only the history of a people's existence through the landscape, but also succeeds in viewing that history from the perspective of a woman as opposed to the stance of patriarchal bardic omniscience adopted by remembrancers of the nation in the past. Her work is soft in its hues of colourations, 'staining' might be a better word to describe the application of paint, contrasting vividly with Kyffin's heavier plastering.

Mary Lloyd Jones works from the basis of intimate knowledge of the myths and stories that come from the land (her father was a renowned local storyteller). Human history goes back as far as the Roman mines in the area and earlier to bronze age settlements, and to those unknown people, to whom the artist relates, who were there before the Celts. It is a locale where historic figures were born and reared, poetry written about certain places, ancient moorland and forest. Each is given its footnote in history,

and it is the awareness of that rich tapestry of folk memory, *cof cenedl*, that is made manifest. In paintings like 'Mineral Mountain', which includes traces of ancient Ogham lettering, you sense that these are maps of a deeper knowledge, and in that way they resemble Australian aboriginal paintings that represent the landscape in symbolic form. It would be hard to achieve that level of deep memory, one feels, without a thorough immersion in the Welsh language. Nigel Jenkins says of her in an essay 'Singing the Landscape':

> Mary Lloyd Jones is neither land locked nor fixed in history: the past for her, as for Iolo Morganwg, whose bardic alphabet inscribes shape-shifting messages across her landscapes, is an activist in the present.[5]

Geoffrey Olsen, born in Merthyr Tydfil in 1943, is better known to other artists and to intellectuals than to a wide popular audience. He is a painter of more pronounced abstraction, whose work invokes the landscape rather than illustrates it. The paintings often bear titles that allude to particular places: 'Florence' (1992-97), or earlier works like 'Cyfarthfa Tips' (1988), and they are often worked on in series. In his set of paintings, the 'Extramural Series' (1995-2000), as the title suggests, the artist engages with his work almost academically, as if writing a thesis, methodical and analytic as well as poetic and improvisational. The thesis on a particular landscape, explores that landscape not through direct representation, but through the systematic creation of a parallel on the canvas. These are landscapes that are both external and internal, or perhaps, they begin as references to certain places and events and then become internalized and become landscapes of the mind. All the while, the process of constructing the image is mediated by a system devised by the artist, allowing for the repetition of layers.

'Cyfarthfa Tips', is part of a cycle of works called 'The Place of Burial' which "extended previously established ecological themes to encompass issues of personal and collective memory, in relation to place and the cycle of growth, decay and regeneration".[6]

These landscapes are of his home area, which he returns to often from his extensive residencies abroad, most notably perhaps at the University of Florida in Miami, where he is witness to the cross currents of Caribbean (in particular Cuban) influence in art as it enters the consciousness of North America. The ambition of his work goes far beyond a topographical likeness of the artist's *cynefin* (familiar territory). It is, in his own words, an

> attempt to fuse intensely felt responses to particular landscape locations, experienced at several distinct points in time, into formally cohesive works which allude to both their landscape sources and their physical production.

The fusion that he talks about is achieved by working and reworking the paintings over a period of time so that they are literally composed of layers, palimpsests of painted surfaces that mimic the layered history of a landscape, of a place. The paintings are re-enactments in a sense, which also become places in their own right.

It is inconceivable that Wales' rich and varied landscape, contained within such a geographically compact area cannot be a source of inspiration for artists working today or remain so for artists of the future. The methods of engagement may change, bringing in lens-based techniques and performance aspects. What does not change is the need to establish contact with memory and its relevance to identity even within work that ostensibly rejects such propositions. Landscape has to be seen as the location of that identity.

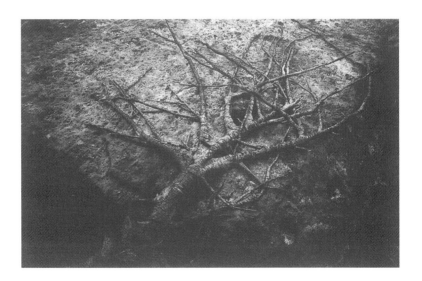

Aled Rhys Hughes, photographs taken in Tryweryn Valley from the series 'Wrth chwilio am Gantre'r Gwaelod' (Whilst searching for Cantre'r Gwaelod) (1992-1995) 40x60cm each

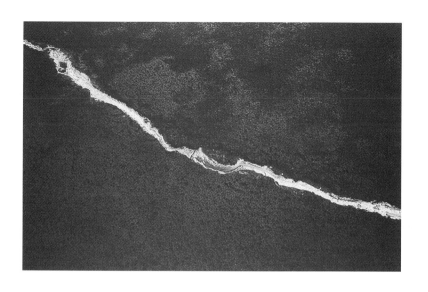

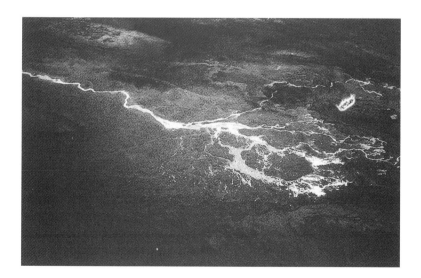

1.4
THE TRAUMA OF TRYWERYN

In the make-up of any nation or community, there are important physical and conceptual sites that contain the essence of a collective memory. The French historian Pierre Nora[1] identifies the sites where memory resides as a *lieu de memoire*, (a physical and conceptual site, the realm of memory). This term can apply to

> any significant entity, whether material or non-material in nature, which, by dint of human will or the work of time, has become a symbolic element of the memorial heritage of any community.

He makes a distinction between memory and history, claiming that "memory is life" whereas "history is the reconstruction of what is no longer". Memory is vulnerable to appropriation and manipulation. It can also lie dormant for long periods only to be reawakened suddenly. The *lieu de memoire*, whether symbolic or functional, is the product of interaction between memory and history. It displays the exciting quality of being able to change, to resurrect old meanings and generate new ones, along the way establishing unpredictable connections. Interpretation of these sites by creative artists, whether painters or poets or film makers, is a prime catalyst in their regeneration.

A nation with a history as long as that of Wales will have many such sites, both rooted and portable. Cardiff Arms Park used to be one, the Millennium Stadium might become one. Caernarfon Castle is one, and Cader Idris might be one. Then there's Curnew Vosper's 'Salem', or the slate strewn slopes of Blaenau Ffestiniog. One site however seems to have preoccupied artists and poets uniquely in recent years. That site, or what we see of it now, is a lake in Merionethshire. Not the naturally formed Llyn Tegid, known to the English tourists as Bala Lake, but the reservoir a few miles up the river Tryweryn. Surely for artists drawn to this lonely

and beautiful spot, nestling into the bulk of Arenig mountain, the tendency would be to paint it in the romantic light of earlier visitors like J.D. Innes and Augustus John. Not so. Few contemporary artists choose to represent the place as scenery in the way of traditional landscape; rather they seek to uncover the 'spirit of place' by connecting with the events that happened there. For contemporary artists, the site itself no longer appears uncontaminated – the objective landscape, the view, has become a signifier.

Unlike the other sites mentioned, whose history speaks to us directly, Tryweryn's hold on our imagination is subliminal, a memory submerged, much like the village of Capel Celyn is submerged under the dark waters of the lake. Significantly, the Tryweryn story, being the story of a drowned land, invites comparison with many early myths and folk tales of Wales. Legends of lakes that are gateways to the other world, or of lakes created overnight as punishment handed down for immorality. Both types of legend are associated with Tryweryn's closest neighbours, the former with Llyn Arenig, the latter with Llyn Tegid. Would it be too fanciful to imagine that in a few hundred years, Tryweryn will become a part of that continuum of folklore? Might it not be seen as a punishment for apathy or failure of the will? One is reminded by a plea from an early Welsh poet to have the land covered by the sea before the Saxon invaders could possess it.

Period black-and-white photographs provide us with images of the events associated with the drowning of the valley, but the passage of time has given them an interesting patina of age. The events took place in the late 1950s and early 1960s, but they could as well have been the 1930s. There are pictures of marching protesters, including children, holding banners on the streets of Liverpool (the lake was to provide water for the inhabitants and industry of that city). But despite eight years of protest by the inhabitants of Capel Celyn and their many supporters (Eamon de Valera among them), the plan to evacuate the village, level the school, houses, post office, cemetery and chapel, and flood the valley went ahead. Every MP in Wales voted against the decision, to no avail. The affair highlighted the cavalier way in

which Welsh land, people and concerns could so easily be set aside when it came to the needs of the (English) 'common good'. At one point in the planning stage, the dam was to be built on the river Dyfrdwy and not the Tryweryn, which would have placed the town of Bala, the village of Llanfor along with all the farms in the valley under a massive lake that would have stretched from Llandderfel to Llanuwchllyn. Bessie Braddock, the pugnacious MP for Liverpool, amazingly claimed in the Commons:

> Liverpool did not decide on a site for the scheme without consulting those living in the district. Liverpool did not 'walk in' without some sort of approach and did not do anything until it received the permission of the people in the area.[2]

When it became clear that appeals to Liverpool City Council and Westminster were to no avail and that peaceful demonstrations and the democratic process had failed, some took to more direct action. The electricity transformers at the dam site were twice sabotaged, once in 1962 and again in 1963 and three men were arrested for causing an explosion which hindered construction work on the dam. The high profile opening ceremony was abandoned after three minutes due to the strength of opposition; police had to protect the Liverpool councillors, and the Free Wales Army made its first appearance. Too late to save Capel Celyn.

There was a collective sense of shame and guilt about the outcome, realisation of impotence and subservience awoke a new and more defiant political stance. It galvanized a sense of national identity. This strengthening of resolve turned into an active campaign over the issues of the Welsh language and political self-determination.

At the time, there were protest songs, notably Huw Jones's 'Dŵr', and a number of poems written in *cynghanedd*. Among the documentary photographs there is a telling image of the half-demolished chapel, with only traces of paint on the wall to show where the pulpit once stood (reproduced in Einion Thomas', 'Capel Celyn')[3], and there are the cartoons of E. Meirion Roberts of Bala. But despite the presence of a talented local artist, Ifor

Owen, on the protest committee, the response of visual artists came much later, and very much as a reaction to the aftermath rather than the event itself.

This can be explained in part by the fact that artists often need a degree of distance between themselves and their subject matter. But it is also true that, until the arrival of Paul Davies and the Beca Group, overt political issues were rarely seen as source of material for painters and sculptors in Wales. By the 1990s however, Tryweryn – or Capel Celyn – was already achieving a mythic status in art, as it was in society more generally, coming to represent a universalized notion of morality and injustice, which nonetheless remains personal to artists from Wales. In some respects it verges upon being our Wounded Knee, our Bloody Sunday, a symbol for the political repression of our community and of protest and resistance. Photographs by Marian Delyth, for example, are reproduced as posters, incorporating poetic elegies, that one can imagine adorning the walls of students' rooms in halls of residence.

Perhaps it was Aneurin Jones, the artist of rural scenes, of farmers at market, who appropriately was the first to draw attention to Tryweryn in art in a painting depicting the famous graffito on a roadside wall near Aberystwyth: 'Cofiwch Dryweryn' (Remember Tryweryn). The graffito itself has been made a memorial by the *werin*, one regularly attended to, with the paint given a new coat every so often.

The artist Ivor Davies cites Aneurin Jones's painting as an influence on his own study of the subject, 'Tryweryn a John Jenkins' (1997) in which he presents a version of the drowning of the valley which foregrounds not the people of Capel Celyn, or Gwynfor Evans who was an early protester of the cause, but the fringe figure of John Jenkins who represents the more radical, revolutionary response, that came later in the day. Jenkins (who was jailed for ten years in 1969) quickly acquired a legendary status in Wales and is presented by Davies as a cultural hero, a Michael Collins perhaps, if not a Che Guevara. The coloration and composition of 'Tryweryn a John Jenkins' has the quality of a quattrocento painting, with the figures standing on the left

pointing towards the dam wall, focusing our attention into the picture in the way that the figure of John the Baptist was often used in fifteenth century paintings, pointing to the infant Jesus, or to the pietà. The sense almost of religious mysticism evoked here points also in the direction of the national heroes depicted in postcolonial Latin American art.

A second painting by Ivor Davies on the same theme has a pyramid of figures, headed by John Jenkins, rising upwards in the centre of the painting, mixing metaphors in a way that would go down well in Cuba where monumental Communist statement is effectively combined with Catholic iconography. In another piece 'History Curriculum' (1993) or as it is more tellingly titled in Welsh 'Hanes Diddewis' (No-Choice History), the sense of political involvement is more clearly integral to the work – bits of paper and pencils hanging on string are provided as invitations for comment, so that the painting becomes a cross between a voting booth and a votive object.

A painting that I worked on in 1999 inadvertently became attached to the same theme. 'Dam/Pont', can be read as an interpretation of the aftermath to Tryweryn. 'A fo ben bit bont', a reference to Bran the Blessed in the *Mabinogi*, has become a saying in Welsh meaning "whoever is head [leader] should also be a bridge". In the context of the painting this suggests the transformation of the dam into a bridge which allows opposing factions to unite, or for water to flow freely underneath – a progressive leap just as the damming of the river Tryweryn and its repercussions eventually helped lead us to the political improvements now in place. In the painting the crosses supporting the bridge indicate a casting of votes (and a narrowly-achieved devolution). A Janus-headed colossus, the spirit of place perhaps, purposefully and symbolically strides over the spindly bridge, toward our collective future. The only colours, in a predominantly black and white painting, are smudged bands of red, white and blue on the left border and red, green and white on the right border. The diminishing perspective point leads the eye through to the back of the picture, as if along a straight road surrounded

by mountainous darkness. The converging linearity meets at a point of rupture in the dam wall. The vanishing point thus also paradoxically suggests a 'source', becoming simultaneously the future and the past. In the painting, references to the dam at Tryweryn suggest frustration, anger, pent up emotion. The release of this emotion as protest, however, caused politicization and created a bridge to the future – 'a fo ben bit bont', but in this case, a dam becomes a bridge.

The work of David Garner is strongly social and political in content. Having dealt at length with the mining industry, its demise and replacement with Japanese high technology industries, this Valleys-born artist has also turned his attention in one assemblage, 'History Lesson 2: Tryweryn'(1998), to the flooding of Capel Celyn. He depicts Tryweryn by using an old tin bath with a tap standing up in it; inside the bath he places an ancient telephone and a Welsh bible, a school bell and a sheep's skull, *llinell ddwr* (water-line) is written around the rim. At first sight the piece seems to lack the authentic fire which we derive from his statements on present-day culture in the Valleys. His engagement with the subject, however, does indeed come from his own 'square mile'.

> It's interesting from my viewpoint that the first people to take direct action were two men from the locality where I grew up, an engineer, David Glyn Pritchard from New Tredegar and David Walters, a miner from Bargoed, who incidentally were not Welsh speakers.

The length of time that often intervenes between an event and its visualization by artists can result in the historic event becoming transformed, given the status of a myth which represents more universal issues – land rights for instance, dispossession and dispersal, indigenous rights, core identity and colonialist assumptions. If this happens, the event becomes a microcosm of larger problems that threaten to engulf us here in Wales and elsewhere – a site that bore witness to colonial imposition acquires new meaning as a place of memory for the colonised.

When the message of a work is less intrusive and didactic, as in Tim Davies's elegiac 'Capel Celyn' (1998), then the question of

authenticity becomes superfluous. This floor piece won the Mostyn Open purchase prize in 1998, but was sympathetically viewed in an exhibition also called *Capel Celyn* in the Spacex Gallery in Exeter in 1997. This surprised the artist somewhat, proving that the mythic nature of the work and the historical events it alluded to (supported by accompanying text) could be well received outside Wales. This is not art that is 'about' history, nor does it hijack history in order to create a message. The message is inherent and self-contained. It is also minimalist in the sense that it is pared down completely to one element, and that element is repeated over and over in a labour-intensive process which the artist undertakes himself. The viewer sees a field of wax nails, a carpet that seems to hover in a ghostly way across the gallery floor. The original nail, from which these were cloned was retrieved from the lake by another artist, Osi Rhys Osmond. In the catalogue essay for Spacex, Alex Farquharson writes

> Art on the margins can still act for the community in place of absent governmental or media representation, and one cannot help feeling that in Davies' hands what began as a single rusty nail that was duplicated by wax casts, has taken on the votive function of a candle in a church for the lives dispossessed at Capel Celyn.

The sculptor John Meirion Morris, born a few miles from Capel Celyn, has proposed a towering memorial on the banks of the lake. His maquette evokes an ascending bird, one that brings to mind Oisin Kelly's sculpture 'The Children of Lir', which commemorates the Easter Rising, in the Garden of Remembrance, Phoenix Park, Dublin. Both sculptors depict the moment of metamorphoses from human to animal form as a visual metaphor for political liberation, the gaping mouths of a lamenting choir adding an air of grief to Meirion Morris's work. Its possible installation on site has caused great argument, due in part to a process of deconstruction in recent years, which involves an attempt to counteract the romanticisation of the Capel Celyn story. Some have suggested that the community was

doomed anyway, with unsustainable subsistence farming and diminishing prospects for the young people. This has led to some resistance to the commemoration of the events with a heroic sculptural monument on this scale.

Photographers, amongst them the eminent Magnum photographer, Phillip Jones Griffiths, have contributed to the emblematic status of the site. Griffiths' photographs from the 1960s featured at the 2001 National Eisteddfod in Denbigh, make the place look like a Bosnian war zone, with locals taking on the guise of dispossessed refugees. Contemporary photographs by Richard Page on the other hand, show how the passage of time, and generational differences, can lead to a more individualistic examination of the site. Nonetheless, Page was drawn to Tryweryn by its symbolic significance. In his exhibition catalogue, *Landscapes from the Tryweryn Valley*, he says;

> Now that most evidence of Capel Celyn has vanished, these images explore the symbolic currency of history itself. They examine the environment in a forensic manner, aiming to question the traditions of the picturesque landscape and replace it with political and cultural scrutiny, a twentieth-century version of the Sublime.

In these photographs he uses the *lieu de memoire* as a means of testing art itself – in particular, the Romantic, Picturesque traditions of the 'rural idyll'.

'*Wrth chwilo am Gantre'r Gwaelod*' (Whilst searching for Cantre'r Gwaelod) is a photographic series begun by Aled Rhys Hughes in 1992. In one sense his work deals with the geo-climatic concerns of what are sometimes called deep time and shallow time. As he explains, the highest mountains were once below sea level, before they were subject to uplift, and sea levels themselves fluctuate dramatically. In Wales, there is the added dimension given by the legend of Cantre'r Gwaelod, the drowned lowland hundred, submerged when the gates of a sea wall were left open to the incoming tide. Hughes sees this as a metaphor for cultural submersion, and relates it to the historic drowning of Capel

Celyn, its population displaced and dispersed. There is a sense that for him, Tryweryn is a deep memory in shallow time. In 1995 he visited Tryweryn when the water level was low and the remains of the village discernible. He notes that before the lake was created, all the trees in the area were felled to stop them breaking free and clogging the pumping system. (A large copper plate was also laid down over the cemetery, no doubt for similar reasons.) In a photographic diptych we see the roots of one tree, still clinging onto a large rock, a direct reference to the 'holding onto' of culture in the face of great and overwhelming forces of change.

Recent revisionism, as I suggested above, questions the solidarity of the resistance at Capel Celyn. The view which holds that the people of the valley had no future, and that they were lucky (and secretly pleased) to receive their compensation is still a sensitive subject in the Bala area, but such an argument is, in the end, beside the point – the myth, the *lieu de memoire*, is based on a principle, it becomes a symbol of resistance which helped give rise to a new future. With this in mind, it might be said that Tryweryn was a necessary trauma to the psychological landscape of a people.

1.5
CONTINUING PRESENCES

Nid yw Hanes ond ennyd;
A fu ddoe, a fydd o hyd.[1]

As we move ever into the future we are always based in the past[2]

In 2002 a large exhibition of Ceri Richards' work, accompanied by a handsome monograph by the art writer, and son-in-law of the artist, Mel Gooding, was presented at the National Museum and Gallery of Wales. To augment this occasion, a group of painters to which I belong, Ysbryd, was asked to make new work based on, or in reference to, the work of Richards. This exhibition would be called *A Propos*. The following quotation is from the catalogue text by Museum and Gallery Director, Mike Tooby:

> Bala is looking for processes whereby he assimilates the tradition of which Richards is a part into his own imagery. It is as if he [Bala] is inventing a tradition of references.[3]

Perhaps being born into a minority Welsh-speaking universe, a fragile universe where we are aware that we might be the last generation of natural speakers, we feel the burden and duty of passing things on. As a result we have become inclined to look at cultural history as a continuum. But a continuum unlike the one through which art history has been viewed, through the humanist prism with its accompanying myth of progress, but rather as a connecting life force. Rather than believing in constant improvements, we have tended to revere the great achievements (and achievers) of the past, in order to gain consolation and strength to survive and persevere for the (hoped and worked for) future. In some ways it can resemble an alternative religion, with the National Eisteddfod its apotheosis. Like religion, it brings consolation to its believers, not least of which is a sense of self-value

gained from believing that one is adding another stone onto the building, doing one's bit in a worthwhile project. We therefore need to identify with a builder who put blocks in further down the wall, who felt and thought in similar ways. Translated, the quotation in Welsh at the top of page 47 reads, "History is only fleeting; That which existed yesterday, will always exist."

The reality may well be that we *eisteddfodwyr* are acting instinctively, that what I have described is merely a form of herding instinct, of opting for membership of a pack, nothing more than animal behaviour. The option we have is to choose to align ourselves with this ancient instinct, or choose to ignore it. Like a religion, it is based on faith and not knowledge. I mention this only as an introduction to a piece of writing about visual art that seeks to address my own sifting of the recent past in order to "invent a tradition of references" as Mike Tooby has it; a quotable and particularly Welsh visual art continuum. All artists, whatever culture they come from, respond in one way or another to other art, past and contemporary. Many artists now see art as a complete break with tradition and will be vigorously counter-assertive to the values of the past. I find it difficult to do that without qualifying the assertion. Without the cultural building blocks of the past, there would be no present, and in order to provide a future, we must be aware of, and appreciatively sympathetic to the endeavours of the past.

People whose culture or way of life has been marginalized, or who come from peripheral and minority cultures and feel the need to identify with their own past, or need to reclaim that past, often find that there are no models to follow. The norm has been to look to the great European canon, or to North American art of the twentieth century, but there are many artists who have become unhappy with those examples, and sought different models. Some of the greatest developments in the art of the later part of the twentieth century have been due to these cultural realignments. It has thus become easier for younger artists today to find models, or, if necessary, to invent them. In so doing, they also become models for fellow travellers on similar roads.

Jimmy Durham, Ana Mendieta, David Hammons, Francisco

Toledo, Jose Bedia, Tapfuma Gutsa are a few names who have inspired my thinking and my work as those big names of the Euro-American canon became of less specific interest as models. By that I mean that they were not specific enough to discuss what I felt to be my own condition. In other words, they did not move this 'obstinate Cymric's' heartstring. Apart from those artists from conditions that seemed to mirror my own, I had always been keen to absorb lessons from 'my own', from Welsh artists rather than anyone else.

As a child, access to art was limited, access to Welsh art even more so. In north Wales, there were no Glynn Vivian or National Museum collections; consequently I did not get to see the works of Ceri Richards, David Jones or Augustus John in the flesh. I mention Ceri Richards first, because out of all three vaunted Welsh talents of the twentieth century, his work seems most apposite as a source of inspiration for my own, although it is only very recently that I have come to study it closely. It would appear obvious in hindsight that I found his linear method of drawing appealing since it tallies with my own graphic style even if my line cannot, nor seeks to, compare with the fluidity of Richards'. His subject matter (in particular his delving into the Dylan Thomas tropes and the rich mythic landscape of the imagination that, I find, relates to a Welshness that is rarely appreciated in discussions of his work) adds to his relevance in the 'invention of a tradition'.

I think Richards would have condoned my borrowings. He himself believed in the timeless continuity of Art, as Mel Gooding says:

> The history of art was for him a living continuum, and works from any period could be approached as existing in the simultaneity of the living moment, their vital power immediately felt in the present encounter. For Richards painting was a Universe of visual discourse in which living artists drew on the researches and discoveries of great predecessors. The historical art to which he turned for inspiration and ideas existed in the here and now of his apprehension, contemporaneous with that of the masters of his own time. Its subjects and techniques.[4]

As an appendage to that, Richards himself is quoted giving advice to younger artists, a quote which in some way qualifies the above:

> The young painter who cannot free himself from the influence of the preceding generation is headed for disaster. In order to protect himself against the spell of the creations of those of his immediate predecessors whom he admires, he can seek out kindred spirits and find new sources of inspiration in the productions of a variety of other civilizations.

It is clear that by 'other civilisations', Richards was not investing the word "other" with the meanings we might have for it today. He seems to be thinking of the artists of the European past (of earlier cultures) as well as of different cultures. The paragraph goes on to mention the way Cezanne took inspiration from Poussin. That he should mention this example rather than Picasso's appropriation of forms from African art indicates that for Richards, art was an available resource from the past as well as from geographically distant lands.

The celebrated Basque sculptor Eduardo Chillida passed away in August 2002, leaving a body of work which remains eminently international but is nonetheless fundamentally and organically Basque. Whilst the Basques are aware of this and proclaim it, in Wales we would rather cast off our greatest achievements in visual arts, bowing to the London-centric, rather than say, hold on, this artist's work owes its uniqueness to the artist's roots, a way of thinking and seeing. Let's proclaim another truth that Ceri Richards' work owes as much if not more to Wales than to Picasso, Matisse or the European canon. Like Chillida in the Basque country, Richards should be equally celebrated in Wales, since his work is organically connected to that essence of place and character, that very psychology of Wales that links it to Thomas' poetry, to oratory, storytelling and, further back, Celtic art and mythology. This done, I add, not in an illustrative, mannerist way, but intuitively. His comment "I'm a Welshman, a Celt, and what I find lacking in so many artists that I nevertheless love, is the romantic spirit" suggests that he was well aware of this

footing. Like Chillida, he is also an artist who has absorbed and developed international trends without losing his footing, and has added to those trends with his own work.

It may have become a device of the postmodern condition to constantly quote from other sources, sometimes creatively and sometimes lazily. It remains true though, that an artist is visually overloaded. We are increasingly bombarded by other people's visual ideas, as is the viewer. The eye is quick to seek out and make comparisons anyway, that's part of its function in the human armoury. Recognising similarities, in order to assess where we are: "is this our cave, it looks very similar" is the same as "oh yes, I recognize that, that's very Picasso-like".

My own work has influences that range from Cuba to Bangor; the example and philosophy of Paul Davies and the Beca Group has featured all along. Or maybe it was just natural for me to work that way, and it becomes increasingly obvious to me that an artist's style is governed as much by an attempt to harness inbred habits as anything else. Our style is to do with the kind of person we are, not what we aspire to despite our best (youthful) efforts. In Cuba I found contemporary art that sought to imbue the essence and spirit of indigenous traditions into the present, through syncretism creating an authentic continuum. This was exiting for me in particular, since it showed me a way to approach my own tradition.

The Cuban artist José Bedia, now resident in the USA, has gained strength and inspiration from the example of Wilfredo Lam, a Cuban artist of a previous generation. Lam was an artist, contemporaneous with Ceri Richards, who in a similar manner suffered from being compared unfavourably to, or accused of pla-giarising, Picasso. Both artists came from the peripheries to occupy a space on the international stage. I like to think that Lam's adherence to the Afro-Caribbean religion of Santeria, drawing imagery from that source that linked him back to Africa, echoes Richards' search for inspiration in the poetry of Dylan Thomas and the Celtic legend of Ys as revealed to him in Debussy's *La Cathedral Engloutie*. Like Lam, what Richards discovered was

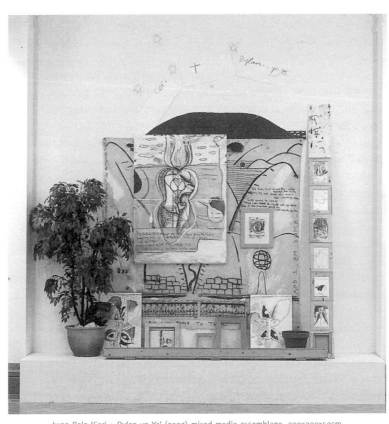

Iwan Bala 'Ceri + Dylan yn Ys' (2002) mixed media assemblage, 300x200x50cm

something he already knew, he naturally taps the same poetic energy that drives Thomas' verse, and he is inclined to see nature as a force that animates from below, driving upwards through death into new life. Both corruption and decay are sources for energy, life, and blossom. There is no death, only metamorphosis, 'living nature' as opposed to the *nature morte* genre of Western pictorial tradition.

In this, and in his almost obsessive repetition of the trope of drowned landscapes, the Cathedral submerged, engulfed by water, he links to a particular Celtic strand of imagery, both visual and mythic. John Meirion Morris has recently completed a study of Celtic art from the perspective of the artist rather than the classically trained archaeologist[5]. We see in the art of the Celtic period a glimpse into their philosophy and spirituality. Away from the ruling logistics of classic Greco-Roman logic, we can once again see the spiral of life erupt from the deep womb of Earth into phallic air and back again, scattering seed wildly. The sexual nature of life is celebrated, as it is in Richards' work, and as it exists in Thomas' poetry. This, although we may have forgotten it, is a religion.

By looking at Richards' work, his sketchbooks and paintings, his own writing and writings on him, and in turn writing about him myself, I have tapped into a lodestone, which allows me also to be reminded of that which I already knew. I have been painting drowned lands and distant islands for years, always have. From Cantre'r Gwaelod to Tryweryn, an unbroken stream, myth and history merge. Thus La Cathedral Engloutie that Richards comes to from listening to Debussy is also a related Celtic myth of Ys, a drowned land. I now had a perfect excuse to quote from Dylan Thomas, something I had avoided doing because it appeared too hackneyed a contrivance. "The force that through the green fuse drives the flower." I knew it by heart. Other works combined Paul Davies' outline map of Wales with Richards' 'Afal Du Brogwyr', a further link, not only to Thomas' poetry, as Richards had done, but to the writing of Emyr Humphreys, his accent on landscape and memory, and his postcolonial treatise on the tradition of

Taliesin. Another recurring motif in the Richards cycle of Dylan Thomas works is the skull, a difficult image to use because it is so potent and yet so easy. Relating it to Richards allowed it to appear in my work, and gradually it becomes grafted in successfully, reappearing in an independent guise in other, unrelated works. "One thing leads to another", as Mel Gooding testifies, is as telling a description of the creative process as anything.

It seemed that I had several options for the NMGW exhibition. I could attempt a large painting, or I could try to engage with the process of collecting and collating, referencing Richards in a more direct way. Several elements came together into one assemblage. I believe I took the option that was truest to my own work at the time; perhaps it was also less demanding than seeking to encapsulate and capture anything as complex in a single painting would have been. A painting has to be more narrowly focused.

All these drawings and paintings done through the first half of 2002, culminate in the assemblage, 'Ceri + Dylan yn Ys' shown at the NMGW. It emphasises the idea of a garden, an idea that comes from the work of both artists, but it is a garden in flux, some things planted not yet grown, some older. It is rather unkempt, but suggests how cuttings might be taken from other plants and transplanted. Paintings and drawings based on Richards' work fuse with earlier pieces. Cuttings grafted on, slowly begin to flower. A painting on a tarpaulin from 1994 is nailed to the wall. Drawings, framed sketches and a large oil painting overgrow this wall-hung canvas. Empty frames and unused canvas suggest a possibility either of continuation, work unfinished or work that will never appear. A tree is added, a trough of peat to emphasise the idea of the garden. It is perhaps here in Ys, a submerged island, an Edenic garden of growth and creativity, that Ceri and Dylan, through their work, live on. Much like the men of the *Mabinogi* who lived on the island of Gwales[6], or Pwyll who spent time in the parallel world of Annwfn. This latter world or 'not the world' as a correct translation from the Welsh might be, seems to be a very similar place to Gwales in that it is a world imagined. It is a place that artists and poets would

find conducive to creativity and reflection, to 'dreaming'. It would probably be hell for those of a pragmatic, practical and worldly bent. What appeals most to me about Richards' work and life is the insatiable appetite for new invention and the restless seeking. It sums up for me the quintessence of what an artist should be. One ceases to be an artist when one becomes content with a formulaic repetition, a mannerist manufacturing of safely saleable commodities. That was not a line Ceri Richards took; while aware of certain limitations, nevertheless pushing the envelope, testing all the time.

Perhaps that this is it, our one and only consolation in a world where many have discarded the comfort of religion, a knowledge that we are not isolated. Time and history do not isolate us, unless we choose to isolate ourselves or deliberately neglect our own history in favour of someone else's.

Ernest Zobole 'Street and People' (1960) oil on hardboard, 69x94cm

1.6
ONE PAINTING BY ERNEST ZOBOLE

It has a title, written hurriedly in pencil on the back, 'Street and People' with the date 1960. Presumably it is one of those generic titles he so often gave his work. 'Ystrad and people' or 'Painting about a Landscape'. It is not signed, but it is undoubtedly one of his, I recognise it from comparison with other works of the same period. It is hanging on a wall of our house, unframed, we decided it looked cleaner, unadorned on a white wall. A simple background gives it breathing space, allowing it to grow in a way I could not have imagined having first seen it propped against a sofa amongst a pile of other paintings and drawings.

On the wall, it seems to have taken upon itself the air of a modern classic. The room is long, about eight metres, and the painting hangs on an end wall, allowing the distance that it requires, though it is a relatively small work, only 69x94cm. It requires that you see it from afar and then you can walk towards it. Thus, its compositional elements, that appear so simple, minimal even, from a distance, slowly grow in detail as you move towards it.

It depicts a scene in a valley town (we surmise, taking a calculated guess). A well lit road arcs across the top half of the scene with another road forking upwards to the right upper corner and another leading south, thus forming a cross, an illuminated cruciform. Above it an abstracted row of houses with slate roofs that vaguely looks like a picture book illustration of Noah's Ark. On the lower right is another malformed building with a brown roof, and the lower left third of the painting is taken up by a dark area of trees with three figures in the darkness, a park perhaps, a fence made of upright lines separates it from the road and beyond stand two simplistically-drawn, almost childlike figures who are lit by the yellowish glow of one street lamp on the left of the picture.

It is painted on the rough side of bare hardboard, the nails that attach it to its stretcher frame are visible from close up, though painted over.

If you look at it with eyes half shut, or with the room left in partial darkness, then the brightly lit road that creates a diagonal across the top half of the painting, becomes like a figure in flight, like a Chagall angel in a dark night sky. A paved traffic island forms a head, or perhaps fancifully, reminds one of a circular window in the nave of a church.

The figures facing away from us evoke the use of figures in paintings by both Picasso and Matisse, seen in an exhibition of the two artists brought together at Tate Modern: Matisse's 'Violinist at the Window' (1918) and Picasso's 'The Shadow' (1953). In the Picasso, the figure could be the shadow of the viewer, cast onto the canvas, or as in Zobole's many other works, it could be the painter himself looking inwards at the painting, an oft-repeated device. We, the viewers, are participants in the same way as the painted silhouettes, looking in at the scene laid out for us.

Unlike many later works, where the town is seen surrounded by sky, sea, the wide world beyond, this painting, following the strictures of his earlier works is more claustrophobic, the edges of the painting cut off the ends of the road, the park and the row of houses. Yet there is a sense of space and distance, of possible escapes. One figure (and it seems to be a man) turns his head to the left, towards the light and what we can imagine to be the direction from which a bus might come to collect him and his companion. A less prosaic explanation might be that he is looking for that which illuminates pedestrian life, or rather, towards the source of that illumination, since this painting has an air of the religious about it, emphasized by the crucifixion 'angel' to which I have referred. I am not aware that Zobole was a religious person, but this painting suggests that possibility. The shadowy figures in the park, seem also to be moving towards the 'light'. One stands at the very base of the lamp, but too close to be illuminated by its light, though we can distinguish an outline, clearer than for those other two, who are almost hidden in the shadow of

the round trees. I remember being told at school never to draw trees that looked like lollipops on sticks, it hasn't bothered Zobole. This is how trees look in the dark, at least in our imagination, in our dreams. In these dreams we return to a more childlike way of perceiving the real world in which we live, and I am reminded of the work of another master of the twentieth century, Dubuffet.

Charlie Burton, a fellow Rhondda Group artist, went to visit Zobole in hospital during his last days, and he remembers his friend saying, "My paintings are the platform on which I stand." These were amongst the last words he heard him say. Ernest Zobole died on the 27th of November 1999.

1.7
IVOR DAVIES: A SHORT LECTURE

It was fitting that the Gold Medal in Fine Art at the National Eisteddfod in St David's in 2002 should go to Ivor Davies. The paintings chosen to represent him there were vigorous examples of a mature career, and also representative of a continuing presence in Welsh art, both lyrical and political. The award served to celebrate an ongoing achievement.

Much of Ivor Davies' history is now public knowledge, thanks to his essay in *Certain Welsh Artists*. However, having said that, I thought I knew all about Ivor, but it seems not. I was recently told that an ex-boxer from Cornwall pays visits to his studio, departing with no less than three expensive paintings at a time. It is known that on occasions he answers his door to visitors in a bathrobe, even in his underpants, but last week I heard he also comes to the door wearing a chef's hat.

Ivor Davies is a multi-faceted man who comes from a fascinating family. By turns he might appear as eccentric, sophisticated, bohemian, academic, a cultured man in a European sense, yet a deeply partisan Welshman. Serious, committed, humorous, he is widely knowledgeable of art and its movements, is an eclectic scholar, practitioner and teacher. His art has more than one mood: angry, political, poetic, surreal, and classical. It references widely, from de Chirico, to Ingres, from Arte Povera to the Quattrocentro, Soviet Constructivism to outsider art by way of Fluxus. He has lived in London, Edinburgh, Lucerne, and Paris. He met Yoko Ono in the early 60s and declined an offer to work with her. His travels have taken him to China, Saudi Arabia, Russia, Galicia, Hong Kong, Croatia and the new republics of the Baltic. He once worked as a hypnotist's assistant.

I first met Ivor and came to know his work in the early 1980s,

and it was a fortunate if not fated meeting. I was inspired and sustained in my own beliefs by this encounter. I had met an artist who believed that the specifics of our shared heritage could be given voice through the medium of visual art, that artists could legitimately express the concerns more commonly encountered in Welsh-language poetry. It encouraged my own engagement with content that was specific to my (our) cultural roots and the contemporary concerns of this marginal and threatened culture of Wales and the Welsh.

Unfortunately I never witnessed his performance works, the auto-destructing artworks of his 'Destruction in Art' period in the early 60s. Since I would have been five or six at the time, it's probably just as well. The images that remain are evocative of avant-gardism. A recent exhibition at the Royal Academy pointed to the overlooked ascendancy of the Paris art scene in the 50s and 60s. New York has stolen that thunder, aided by propaganda, the CIA and Clement Greenberg. Ivor always knew of this. 'Destruction in Art', I would venture, with its propensity for auto-exploding sculpture and general incendiary art was certainly, whilst coexistent, a nod towards Nikki de Saint Phalle and Yves Tinguiley's collaborations on exploding assemblages. Beca, the group he formed with Peter and (the late) Paul Davies, had closer affinities with those Parisian protesting artists than with the New York scene of the time.

I find Ivor Davies' work, its references and ideas, an inspiration. I mean ideas such as the use of indigenous history, myth and legend, and the emphasis on its continued relevance to the present. Its re-invention, in other words, to suit the present situation. To use the name of one of Ivor's pantheon of deities, a process of Iolo Morganwgisation is set in motion. Iolo was the man who, through clever scholarship and even cleverer fabrication, forged a national identity in the eighteenth century, for a Wales that desperately needed it. He gave us our own 'national' pageantry with the Gorsedd of Bards of the Island of Britain. He was another Welshman with keen European instincts.

That Ivor showed an enthusiastic interest and encouraged me

in my work and preoccupation's was and is a source of great confidence. Here was an experienced and established artist, whose views I valued. It was he who invited me into the Beca Group, and later encouraged me to join the Welsh Group. No individual should have to embark on a career in such a confidence-sapping, up and down world as that of the artist, without such valued support. He is, then, what one might call a mentor, but a mentor through example, through 'being' and 'doing' rather than through didactic tutoring. Likewise, he has always been supportive of my writing, which again I value, since he has considerable experience in that world also. He single-handedly produced *Link*, a visual arts periodical for Wales for some time in the 1980s; is an accomplished essayist in Welsh and English and has written not only on art in Wales, but on the Russian Avant-garde. An impressive volume was published in 2002 in Italian, *L'Eta della Avanguardie*[1], an illustrated history of avant garde art in the first quarter of the twentieth century.

There is enough evidence in his paintings and writing to tell us of his deep love of things Welsh, *y pethe* as we would say; literature, myth and politics, religious figures, saints and sinners (though he would undoubtedly question that last proposition). Ava Gardner appears as a young Celtic goddess amongst surrealist standing stones in a work from the 1950s. There are Mabon (Maponos), and Taranis, the Celtic god of thunder. There is Blodeuwedd, the woman made by the hands and magic of men out of flowers, undoubtedly a Celtic incarnation of Lilith the first wife of Adam according to legend. Branwen the daughter of Llyr and her godlike brother Bran the Blessed. Summoning these wraiths from the depth of cultural memory and myth is a risky venture. It has transformed many serious minded attempts into overtly romantic kitsch. Ivor avoids that new age hippie mysticism, which like the Victorian version of Celticism turned something real into something exotically inauthentic. As he says "Celtic mythology, as bloody as its history, has been made fey and diluted by its friends and enemies".

He sums up his artistic philosophy thus:

> Much of my work is about the memory of this ancestral culture, the fusion of ancient history and legend with modern issues of unwritten history and activists who have become modern legends.[2]

The difficulty is always in harnessing history and myth in a way that has the appearance of 'authenticity' of the 'real', and perhaps, in order to do that, you must have a bloodline link to the core of myth. Ivor succeeds in that. It might be a question that the uninitiated may ask: how real is anything in comparison to exploding artworks, possibly the ultimate expression of realism in art. Nothing can be that real, in particular art that makes references to events that only a minority, even amongst Welsh speakers, are cognizant of. It is a role, a burden possibly, certainly a vocation of a custodial aesthetician to be a Remembrancer, to 'keep the legends alive'. There is a certain system that runs through the history of the Welsh, whereby events are not decided on the level of logical pragmatism, but on a logic born from 'prophecy' and synchronicity (to give it a modern term), thus by dint of legend, history and ancestry, Henry Tudor reclaimed the rightful crown of Britain for the Welsh, but his lineage links backwards to Arthur, to Vortigern, to Merlin and Taliesin and through other even more esoteric connections.

All these linked qualifications would have been brought to bear, spin-doctored, to provide him with the right credentials. The same would have happened with Owain Glyndwr, to less successful but far worthier effect. It is by tapping into these synchronicities, by depicting seemingly unrelated yet, to a Welsh eye, completely logical connections, that Ivor portrays the psyche of this worldview.

The wonderfully named Theophilus Evans (1693-1767) published in 1716 *Drych y Prif Oesoedd*, a history that, for the first time in two hundred years, presented a view of Wales as a country with a history distinct from that of England. One phrase of his fits exactly Davies' activities as a member of Beca in the early 70s, at the forefront of the politicization of art in Wales: "*I ddywedyd yn wych am eu hun, a dywedyd yn gras ac yn chwerw ac yn ddiystyr am*

eu gwrthwynebwyr" (telling brilliantly of their own heroism, and harshly and bitterly and contemptuously about their opponents).[3]

The 'colonial' administrators in the outpost galleries of Wales at the time (1970-90) chose not to exhibit such harsh works – and they were works not only harsh in their message, but harsh in their making. Scheduled exhibitions were mysteriously cancelled, it is only in the last ten years that Beca has become somewhat acceptable. But as a movement, its influence is still undervalued.

As well as being a member of a movement, Ivor Davies is a distinguished academic and an artist in his own right. He makes paintings that are attractive enough for hanging in a house as well as a gallery, watercolour still lives, flowers and interior scenes that seem slightly incongruous next to his more radical experimentation with pigments and materials.

The works exhibited at the Eisteddfod pavilion in 2002 highlight the deliberate adoption of stylistic devices that attenuate the theme of the works. In 'Delw Danbaid' (Fiery Image) (2002), the three famous protagonists of the burning of a military bombing school on the Lleyn peninsula in 1936: Lewis Valentine, Saunders Lewis and D.J. Williams, are portrayed as if in a newspaper, or in the religious prints that used to hang in Chapel vestries glorifying the towering *hoelion wyth* (the leading lights, literally translated, 'the eight inch nails') of the Methodist Faith. After the fire they reported their 'crime' at a nearby police station, and there followed a celebrated and protracted court case, which was eventually moved to London, and the three were imprisoned for a nine month stretch. 'The Writing on the Wall I: Destruction of Language and Communities' is Arte Povera revisited, an assemblage of objects on a sackcloth background. There are those who see the cutting of the family Bible in two by an ancient gun (another heirloom) as an act of blasphemy, but they miss the point. The work refers to the larger blasphemy of a culture shred in two, torn apart by the political and social processes that the artist protests about. Its companion piece, 'The Writing on the Wall II: Bombing Poverty-stricken Countries' (2001), exhibited previously at Turner House, Penarth, is a return to Beca 'harshness', and is

inspired by pacifist/nationalist graffiti written on a chapel wall.

Characteristically, Ivor donated his Gold Medal prize money to establish an Eisteddfod award for artists who use Wales' political and social background as a theme and who raise issues. He leads by example. Ivor Davies deserves a prominent place in the history of our gradual decolonisation. Viewed from the perspective of the visual arts; he deserves a central place, a whole chapter. His career spans a period of ferment, flux and upheaval, but Davies is not a man to fear that Chinese curse which he once related to me, "May you live in interesting times".

1.8
THE CASE OF BILBAO

If Cardiff is the capital of a new, forward-looking Wales, it needs to think seriously about its public architecture. This it has so far signally failed to do with the rejection of Zaha Hadid's opera house design. At one point it seemed we might not have Richard Rogers' new Assembly building either. There may be a case for looking to our indigenous architectural tradition for inspiration, as in the case of the Millennium Centre. The crucial point though is that Cardiff (and Wales) must have the courage to commission buildings of striking originality. With this in mind, I returned to Bilbao to see the changes that this city had fostered since I visited there in 1989.

The artist Brendan Burns had informed me that a friend of his had recently moved to live in Bilbao, and was full of enthusiasm: "What an exiting place to move to". Why this change in perception regarding this modestly sized, post-industrial, rainy and rather rundown city on the north of the Iberian peninsula, which, with a population less than 500,000 in the whole area, is not much different to Cardiff and its environs? The answer is Guggenheim Bilbao. This extraordinary building, opened in October 1997, designed by American architect Frank O. Gehry, is the spearhead of a general transformation in the image of Bilbao, which starts with the modern buildings to be seen at the airport on your arrival. As you circle out of the clouds above the city you look down on the scrunched up terrain, like a bedspread crushed by a giant's hand, composed of interlacing valleys and mountains. Like the Welsh valleys, a ribbon of urban sprawl leads to the sea, the city inhabiting a semi-circular curve of the river Nervion crossed by nine bridges. And there, below, lying on a northwesterly corner of this compact city, your attention is drawn to a gleaming titanium steel structure, with forms unlike those of any other building.

On the ground and close up, the Guggenheim can resemble a ship, but it also reflects recurring motifs in Basque visual art, like the knotted rope-like sculptures and images in Agustin Ibarrola's work, or the interlocking block-like forms recognisable from the work of Eduardo Chillida. The building shimmers and changes colour depending on the reflected light, it seems to be growing across the La Salve bridge adjacent to it, absorbing and transforming this rather ugly 70s construction, integrating it into a new order. The next bridge down is a soaring pedestrian crossing by Santiago Calatrava, architect of the new airport terminal.

The history of the building is complex. Briefly, the Solomon R. Guggenheim Foundation wanted to expand its European base, originally hoping to enlarge or build a new museum in Venice, where the Peggy Guggenheim Collection already houses part of its vast collection of modern art. This proved unfeasible and Salzburg entered the bidding, offering to invest heavily in a building. The collapse of the Soviet Union however, somehow eroded the political will for the Salzburg project. On a recce to Spain, Guggenheim Director Thomas Krens was impressed by the determination of the Basque National Government to anchor the development of Bilbao to the creation of a major cultural facility. It must be admitted that this had very little to do with culture, and a great deal to do with economic regeneration. Ultimately, the regional Basque government along with the Basque taxpayer financed the building whilst the Guggenheim Foundation provided the expertise and their collection to draw on. In his fascinating book, *The Basque History of the World*[1], the journalist and writer Mark Kurlanski analyses the history in detail. One of those details being that the City Hall in Bilbao, the Parliament and the Basque Government, all necessary signatories to the deal, were controlled by the Basque Nationalist Party, the PNV. Thus unanimous decisions could be made.

Generally the Guggenheim is seen as a good thing, it has certainly benefited the local economy. The owner of the hotel where I stay regularly (Iturrienea Ostatua in the Casco Viejo, the old part of town, highly recommended) was an artist herself and I

asked her whether there was a feeling of American Imperialism attached to its coming. "For everything you must pay," she said, adding that in a country with nationalist feeling there was always a polemic, "as you must know from your own country". There seems to be a tension between this appreciation of the 'global' concept and aspiration of art institutions like the Guggenheim, and of being true to a sense of Basqueness. A sense of difference, of cultural specificity, that is a very real and palpable thing in Bilbao. Many times she said, as in the case of bringing Hollywood stars over to open exhibitions, "it is not Basque".

This viewpoint is well understood in the Basque country, and forms part of the cultural exchange. Not so back in the good old Yookay where such views are deemed to betray extreme nationalistic tendencies. The examples of Serbia and Kosovo are trotted out as representing 'the dangers of nationalism'. To hold the view that cultural differences should not be lost is not necessarily a 'nationalist' agenda, surely? People who have no concept of the threat posed to minority cultures resort to a moral high ground that proposes an internationalism that is no such thing. 'Why can't we all live together?' means we will always be in thrall to a monoculture. That argument, espoused from such lofty ground, is a form of apathy, an intellectual laziness. It is failure by a static old guard to grasp a fundamental perceptual change that is occurring globally, particularly in postcolonial regions and within Europe. This change is led by the belief not that one culture is better than any other, but that each culture is important and must preserve and develop its own tradition and resist the seductions of an U.S.-led 'global' culture as much as the political agenda of centralised super-states. We all know that there is a growing global economy and a global art and culture that goes with it, and that this is not altogether bad, but is not an excuse to throw away all that unites us with a sense of rootedness and continuity. We must also realise that globalisation is not inclusive; huge parts of the globe are expected to be passive recipients of the monoculture and not participants in its creation.

I certainly felt, on entering the Guggenheim that this, in a

secular world order, was a cathedral (the building was always planned to have the impact of Chartres Cathedral) built to celebrate the triumph of American art, to house on the top floor, a collection that begins with modestly sized European abstraction, Kandinski, Mondrian, Miró and culminates with the massive canvases of American icons; Rothko and Motherwell. 'It may have started with you guys,' it seems to say, 'but it sure as hell belongs to us now.' No Beuys, no Bacon. For anything exhibited within this vast sculptural space, size matters. As the painter John Selway said after a visit, "You have to be pretty damn wealthy to make the kind of work they exhibit in there". The art may not need the building, in fact the building, as in Frank Lloyd Wright's Guggenheim in New York, tends to obstruct the viewing of art. Like the new Tate Modern on Bankside that continues the trend, art is upstaged by the vast and lofty interiors. Despite Gehry's reputed remark to the Basques that if he was to get the job, he would regard the building itself as being more important than the work inside it, the building needs the art to give it *raison d'être* and to turn it into a public space. And it needs big art. Big art is best seen at a distance and this you certainly can do, looking down at Clemente's work from the gallery floor above brought it back to the scale that I am used to seeing it from magazines, and (to my disappointment) it looks all the better for that. Some art is designed especially for particular spaces in the building. Artists such as Sol Le Witt and Clemente are commissioned to make these works that can either be seen as a successful development of the museum idea, or an expensive form of interior design. The visitor to the gallery first encounters Jeff Koons' massive 'puppy' made out of flowers outside the front entrance. In the culture section of the *El Correo* newspaper on the day I was there, there was an article and a photograph of a young Basque artist, Gonzalo Laborda, with a maquette for his own, (wooden) puppy, 'El Perro De Troya'.

True to form, the young Basque artists invited to make site-specific installations on the uppermost floor of the building have created the most interesting and subversive works in the gallery.

The Tower Wounded by Lightning. The Impossible Goal as this exhibition is called, is sponsored by *El Correo* and *El Diario Vasco* newspapers. The title refers to the Tower of Babel myth and how impossible works can never be successfully concluded. It is more than tempting to see this as a comment on the aspirations of the Guggenheim Foundation. One artist, Javier Perez, a native of Bilbao, has hidden the interior architecture of the Guggenheim with sheets of MDF board, cheap timber joists and DIY paraphernalia. Doors are placed onto the wall where there are no openings to enter or exit. It is as if someone has moved in and is determined to create a domestic unit within the gallery's imposing space, reducing it to the dimensions of a Barrett house. Even out in the street there seemed to be a continuation of this subversive debate, right across the road a shop is dedicated to selling Productos Cubanos.

The beneficial knock-on effect of having this extraordinary, potentially dangerous building in Bilbao is currently weighing the balance in its favour. More funds have been made available from the local government towards extending the Museo de Bellas Artes, a building housing a permanent collection of Basque art. Artists' projects, theatres and other cultural venues and events are being seen as valid business ventures, supported and encouraged. The Basque government, by nature conservative, has suddenly become aware of the way this art can open them up to the world. Artists, of course, would like to see this new appreciation of art extended beyond the business angle, but at least, they say, it's a start.

The improvement has been drastic; ten years ago the arts were going under. Now art is making its presence felt in a city boasting several new private galleries. The audience drawn in from Europe, America and Japan by the Guggenheim Museum is putting money across the counter at other museums, at restaurants, shops and hotels. Meanwhile, the Guggenheim hierarchy is itself beginning to learn how it needs to operate within culturally specific locations. I noticed for instance, that the Basque language was placed above Spanish, which is in turn above English. The

Museo de Bellas Artes on the other hand, places Spanish above Basque and in many instances has only Spanish. As I have mentioned, locally based artists are given the opportunity to exhibit alongside the permanent and changing exhibitions of international stars. This in turn gives them exposure to an international audience, and the confidence and aspiration, the competitive spirit, that is needed to make challenging art on their own terms. On a more recent visit to Bilbao I saw a rather indifferent show at the Guggenheim that I cannot remember at all. I do however remember a stimulating exhibition of young Basque artists at the Bellas Artes. Whether or not this place put on such shows before the arrival of the Guggenheim I don't know, but I warrant that it has sharpened their critical thinking.

In the final analysis, the greatest impact of having such a building is in the attention it attracts and the image it projects. The Sydney Opera House has it, the Empire State Building also, but these are in cities with many other attractions. In Bilbao the Guggenheim is to a great extent the only reason that many visitors initially come into the area; they are then gradually introduced to Bilbao and the region's many other charms. Just imagine for one minute how a building with such unorthodox and original design in Cardiff could transform the image of the city, how it could focus the international gaze. One minute might be as long as we can hope to dream in Wales unless we develop a more adventurous vision.

2.1

NOT THE STILLNESS: THE WORK OF BRENDAN BURNS

"Butcher's Boy Made Good" was the typical headline to an article by Clive Betts of *The Western Mail* when Brendan Burns won the Gold Medal in Fine Art at the National Eisteddfod of Wales, Llanelwedd in 1993. He won his second, the first double winner since Brenda Chamberlain (1951 and 1953) – in Bro Ogwr in 1998. His other honours include the University of Glamorgan Purchase Prize in 1999 and Welsh Artist of the Year in 2000. A lot of accolades for a 'butcher's boy', the basis of which is that Burns for a time had a Saturday job in a butcher's shop whilst studying at Cardiff College of Art. Every year with great sensitivity and monotonous regularity, our 'national news-paper' chooses to employ the dubious talents of their political commentator to create 'newsworthy' print about the winner of Wales' top art award. A serious critique is obviously too much to expect. Other memorable headlines included "Daubs Win Prize" (Sue Williams, 2000) and "Porn Lady Wins Gold", the latter referring to my own work in 1997.

To extend the image, it might be too much to say that Burns 'butchers' the landscape he paints, but he certainly cuts it up into smaller and more palatable meaty fillets. He is a 'painterly painter', who moves the physical material of paint around his large canvases and small boards with the sureness and strength of a butcher chopping a leg of lamb with a cleaver. But that's where this comparison ends.

At first sight, the paintings appear to be abstract, even abstract expressionist, concerned with their painterly being and with little or no reference to the outside world. They are either small works in oil and wax on board with embedded perspex pieces, or very large single canvases or diptychs. How does the viewer enter the work?

When I visited an exhibition of new paintings at Newport

Gallery, a storyteller was busy regaling a crowd of primary school children with tales that ostensibly grew from looking at the paintings. "Starfish colours," she was saying, as the children were encouraged to enter into the painted world via stories of the sea. A video ran on a monitor in the gallery, showing a deserted Pembrokeshire beach, cliff face, running water, pebbles, reflected sky, tide marks in the sand. A series of digital photographic prints emphasize this link – and we look at the paintings again and see similar marks and processes. But the paintings are never just this and we have to ask, do they need such a way in?

These days, putting your art into the public realm increasingly involves 'statements of intent'. Brendan Burns realizes that his paintings, hovering as they do between abstraction and figuration, need some explaining. Ultimately however, the beach is for him only a starting point, as it should be for the viewer. As he says;

> There has to be another response to these works other than a simple recognition of time and place. They have to be more primeval than that, they have to 'touch' you. I aspire to a painting which communicates to everyone, whether you know Pembrokeshire or not.[1]

The title of the large diptych that gave the exhibition its name: 'Not the Stillness', describes the paintings well. They are not still but rather full of restless movement, sudden dips back from the surface where paint flows and drips like the natural phenomenon that it is, without the husbandry of human touch. Left to itself on a vertical canvas it flows downwards. Some passages smudge and blur, other marks are obviously made by brush and hand, punctuating the background field, drawing all into focus again and giving the coherence of an overall design which differs between each painting in the way that the stratification of a cliff face, or the patterns of rock and vegetation, differ from one location to another. But these paintings are not reproductions of any particular place – they mimic the action of nature, they are 'equivalents' as Peter Wakelin suggests in his catalogue essay.[2] The artist himself explains this equivalence: "the fine line which separates

figuration and abstraction underpins this work. A close relationship with the Pembrokeshire coast has provoked a large and ongoing series of paintings." His next sentence might be preceded with a but:

> paint in fact, is a major concern in itself. Process is integral, both in painting terms as well as 'within' the landscape. The concept of space, both actual and pictorial; implications of time and place; issues within movement, weather and light; alongside gesture, glimpse and memory are requisite themes within these paintings.

"Diamonds," the children say in response to the storyteller's plea for words, "waves", "salt" – words to make a story with – "a diver", comes one inspired voice. True, there is a sense in which we want to dive into these paintings. Like Monet's famous water garden series – which are forbears of these works – there are no central focal points, you can enter anywhere; there are no edges and no middle. There is a surface which is paint and wax on canvas. What we have is an allusion made to the surface of a beach (as the TV monitor rather insistently tells us) and the titles of the works. There is also a painted composition; each one different even though the colours are virtually the same in each of the nine large works on display. And beyond the surface, what is there? How deep can we go? Where does the ground finish and the sky begin? Light reflects outwards, the sky is reflected in the ground, the world in a grain of sand. We begin to notice differences: 'January' (2001) is more graphic, more 'drawing', the artist's calligraphy is evident, and it is almost a shock to notice little doodled bushes amongst the paint. 'Seabelt Shimmer' seems to have a central motif, a pagoda-like structure, a thick daub of laverbread green; purple tooth-like protuberances drip, defining the central portion from the Turneresque background haze.

John Cowper Powys praised Wales in all its aspects, including the rain. It was better than that which falls in Dorset, he said, where he had lived previously, which "drenches you to the skin". Welsh rain was "mountain mist rain, soft vaporous rain, rain that is really entering into a cloud..."[3] Peter Wakelin mentions the

"shifting veils of rain". Titles of paintings include 'Misty Wet with Rain' and 'Squally Squint'. These paintings are as much about rain as they are about beach, or perhaps that is the abiding quality of a Welsh beach, a beach on the western edge of Britain. The meeting of mountain rain and tidal salt, gray mistiness, seaweed greens and slate. The beach, the horizon, the sea, the cliff face, all entering into a cloud.

You don't need a critical intelligence to appreciate these paintings. If you can see landscape and feel it, respond without memory, dwell in the here and now, then you can use the same senses in front of these paintings. Geological time is sometimes split into 'deep time' and 'shallow time'; human time can be split into 'deep memory' and 'shallow memory'. In terms of Welsh landscape, Burns works with 'shallow memory' set in 'deep time'. In the case of such work, there is refreshingly little need for background textual assistance, of myth and deep memory, of the specific events of human history. It is not even necessary to know the artist's personal history. This work is not about statements or autobiography, it does not demand of the viewer background knowledge, a reading of signs and symbols in a schematic sense, or of politics. Check your baggage at the door. In a statement, the artist says

> It's our genetic make up, it's being human, being alive to the world, that I wish to tap into. The paintings are about being human, and the act of creativity. They are about contemplation, they have to be sensed as well as experienced, they're physical paintings. The 'spiritual' response and purpose is central.

In an art world that has sought to relegate painting to the dustbin of history and elevate the 'more relevant' newer technologies of video and photography, installation and text-based works, this no-nonsense approach to the essential spiritual dimension of painting – both in its execution and the experience it communicates – is proof that painting's primeval roots cannot be easily excised from human need and experience. Painting is thinking, it is a presentation of what you do not know as well as what you do know. 'Touch' within these paintings is crucial.

"Painting is an Art," says Kandinsky "and Art is not vague production, transitory and isolated, but a power which must be directed to the improvement and refinement of the human soul". The artist's choice of Kandinsky as mentor is illuminating, as is his co-founding of a group of painters known as Painting Ysbryd/Spirit Wales, who have set about exhibiting widely within and outside Wales, participating in the Interceltique Festival at L'Orient in 2001 and 2002 and showing at the National Museum of Wales in the exhibition *A Propos* in the winter of 2002. It is a group that agrees with the view that painting has the capacity to 'touch' the human spirit directly, without recourse to thought, theory, dialectic or deconstruction.

The nine artists in the group range widely in their methods. Co-founder John Uzzell Edwards might be said to employ 'deep memory' in 'deep (human) time', deriving inspiration from Celtic Christian illuminated manuscripts and older stone crosses and carvings. Other artists involved are Sue Williams, John Selway, Martin Jones, Glyn Jones, Peter Spriggs, Sarah Bradford, and myself. In the expanding field of visual art practice in Wales, painting has a momentum of its own. The art historian Norbert Lynton says in his catalogue essay to the inaugural *Ysbryd/Spirit* exhibition in Cardiff's Howard Gardens Gallery in 1999:

> It seems to me, from repeated contacts over the years, that Wales is rich in painters, Welsh and not Welsh, and that these painters work well in Wales.

Whichever way you choose to interpret that statement, do we only "work well" in Wales, do we not travel well? It remains true that the venerable landscape painting tradition here, which reaches a kind of apotheosis in the work of Kyffin Williams, is being re-invented in the works of Brendan Burns, along with fellow artists such as Mary Lloyd Jones, Catrin Webster (despite her recent relocation to London), Geoffrey Olsen, and by a host of younger painters. Painting did not die in the 1960s, as was widely rumoured, but it certainly went into an exile from which it did not return for almost two decades.[4] While painting is still

under-represented in the exhibition programmes of many of our public galleries, a new gallery Bay Art which opened in Bute Street, Cardiff in 2002, is ostensibly dedicated to painting, under the auspices of its director, the painter Phil Nicol. Nonetheless, it must be remembered that even in the recent revival of painting, abstract formalism remains somewhat discredited by the perceived failure of artistic modernism in social and cultural terms.

Like many painters in Wales, Burns benefited from the tutelage of Terry Setch at Cardiff College of Art. It would be too easy to make comparisons between their work, both deriving their material from the beach, Terry Setch at Penarth. However, while Setch deals with the human detritus on the beach – the litter washed up on the shore becomes, literally, the material of his work, embedded into the surfaces of his large canvasses – Burns avoids all reference to human intervention, all trace of presence. As he says in his conversation with Tony Curtis in *Welsh Artists Talking*; "No footsteps, no debris, no human presence, just myself".

Terry Setch isn't the only artist to record in his work the despoliation of the environment with the left-overs of consumer society. There are the walks of Hamish Fulton, for example, who walks in all parts of the globe, recording the desecration of nature. Does this mean that Burns is shirking his responsibility to the environment, to the cause of the artist as social conscience?

It was not always so. As the son of a Protestant Army officer father and Irish Catholic mother, his early work was redolent with direct reference to the Troubles. Born in 1963 in Kenya and moving from one Army base to another, Northern Ireland must have been a constant background to his life. When his parents separated, his mother brought him to Cardiff. Politics and Religion featured heavily in the work produced during his time at Cardiff and at the Slade in London.

When, however, he returned to Cardiff after a brief stay in New York, he embarked on a series of paintings loosely based on the many drawings and photographs he had taken of the city. This location is not in itself important. Like Pembrokeshire, Gotham City is just a starting point in a process of making paintings that

are essentially about painting. Retreat into pure painting came from the realization that this had always been his main concern:

> I celebrate the painting. I'm a painter. Romantically, being a painter has always enticed me, more than the landscape. Influences, or affinities with, I should say, de Kooning, Gillian Ayers, Hodgkin. Painterly painters. They are the images that make the hair stand up on the back of my neck.

Although his work moved in this direction, Burns the man is not some kind of apolitical aesthete – he remains a political animal. He is passionate about art in Wales, true to the spirit of the Eisteddfod (and this is political in Wales), ending his conversation with Tony Curtis with a plea for a museum of modern art: "for contemporary work produced in Wales on an international stage". Issues, however, can stand in the way of the act of painting, forcing painting into a secondary role, diluting that gut-wrenching physicality which is the response that bypasses the intellectual, making the hair stand on the back of the neck. Like the late Modernists, we might say that painting, pure painting, is elevated above the temporal issues of our time, indeed to the realm of the spiritual, the sublime. These paintings are an escape from landscape that is overloaded with history, there are no horizons and therefore no context for narrative except for the narrative of the paint on the canvas, the evoked connection with looking down at the beach at your feet and seeing a sky reflected there. They demand physical and emotional rather than intellectual responses. This is no criticism – in many ways the paintings mimic the psychology of all those walks on the beach in the misty rain. We are not there for the sun, or for play, we do it for the good of our soul, retreating from thought-overload and from self-absorption to lose ourselves in nature.

Ultimately, painting is its own world. As the Scottish painter Alan Davie has intimated, you might finish a painting, but you never finish painting. The work of Brendan Burns is a reaffirmation of the painterly. Butcher's boy or quester for the holy grail of modernist art. Each may involve an element of myth – the latter has the semblance of truth.

Brendan Stuart Burns 'West-shadow' (2001) oil, wax on board, 21x34cm

David Hastie 'The Secluded Stage' (2000)

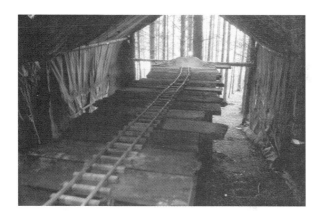

'Movement of Sand' (2002)
mixed media assemblages, dimensions variable

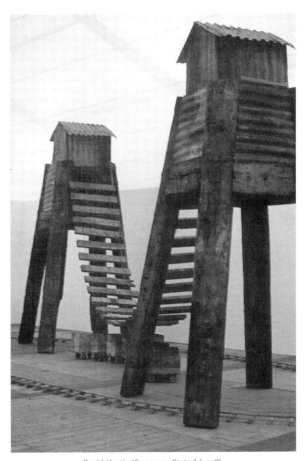

David Hastie 'Crossover States' (1998)

2.2
CROSSOVER STATES, MATERIAL MEMORY:
ANGHARAD PEARCE JONES AND DAVID HASTIE

This year (May 2001 to May 2002) has been designated The Year of the Artist. Here in Wales you may be forgiven for not knowing that. Though well funded in England and Scotland, the Arts Council of Wales seems to have failed to pull in any extra resources to celebrate the artist in Wales. Of course, this no longer surprises us. A large event planned by The Artists' Project that would have partly remedied this no-show situation and made some impact in Wales failed to secure Lottery funding. There seems to be a failure of faith on the part of the Lottery body in Wales to believe in the artists' ability to make things happen. So many conditions have to be met in order to secure this funding in the first place that the envisioned project becomes changed beyond recognition. The making of art becomes a secondary thing, secondary to education or market research. The artist is expected to become a social worker. By the end of the process of application, any creative energy has been sapped, there is no *joie de vivre*, no energy left to make art happen.

The event, *Site-ations 3,* was due to occur on many sites within Wales, including a disused quarry in Gwynedd, the Penrhys estate in Merthyr, locations in Swansea and Cardiff as well as smaller sites, on the Pembrokeshire coastline, in the Berllanderi sculpture workshops and Coed Hills Farm near Cowbridge. Artists from Wales would work at these sites alongside artists from Europe and the U.S. It would be the third event of its kind to be hosted in Wales, but whereas the previous events were centred in Cardiff, this would take in the whole country. One of the reasons given for declining the application was that the organisers could not possibly handle such an amount of money. We are talking about a sum that would not buy a two bedroom house in Cardiff.

The good news is that the positive response of Swansea Council and particularly Swansea Museum and the Glynn Vivian Art Gallery persuaded the organizers in Swansea to attempt a festival of their own. They invited high profile artists from Ireland, Scotland and France to work alongside a selection of Welsh artists. The event Locws International took place in the last week of August and first week of September 2001, and was supported by the Arts Council of Wales. In the spirit of this, I felt that two of the artists associated with the initial Artists' Project plan should be introduced to a wider audience. David Hastie who, along with Tim Davies, is organizing the Swansea event, and Angharad Pearce Jones who, alongside Valerie Wyn Williams, was to be an organizer of the slate quarry site in the north.

Some time ago David Hastie discovered a trunk full of old toys in the attic of his mother's house, he revisited his childhood in that dark and sheltered place. Hastie is a necessary artist. If art is a means by which society can look at itself and communicate with itself, then Hastie's work is an essential ingredient of our society's current dialogue. He makes work that is like no-one else's, and this work whether in a conscious or unconscious way, touches on some truths about the general and universal human condition, whilst utilizing a vocabulary drawn (literally) from his own back yard. After completing his degree at Cardiff he returned to the family home near Swansea. The farm where he lives provides space for making work but this arrangement also means that he has been forced to face his background head on. Many artists can leave this behind, pick and choose their environment. David Hastie has to confront it, explore it, and use it.

The material Hastie uses, the creosote-stained or weather-bleached railway sleepers and timber planks, the malleable lead from which he fabricates castles and railway trucks, are redolent with references, direct and allusive, to the industry of the past. A past recreated from a child's viewpoint. These materials are hewn and nailed together much like the quickly-put-together structures that sprout around farmyards. Sheds and fences, a stack of hay bales in a corner, rickety sheep pens falling apart. As he says in

the catalogue to the *Superstructures*[1] exhibition at Cardiff's Centre for Visual Arts:

> I share my studio with a tractor and a couple of horses. There are also 500 bales of hay in there and I think it won't be long before I put 500 bales of hay in the gallery.

This was indeed his plan for *The Secluded Stage* (2000) an exhibition in Swansea's Mission Gallery, his first one-person show. The installation incorporated a stack of bales, wooden platforms and joisted towers.

I first saw Hastie's work in a derelict red brick industrial space in Canton, Cardiff that used to be Vaughan's Laundry many years ago. The Artists' Project, who had studios upstairs, had appropriated the ground floor as a temporary exhibition space in 1997. The first thing I noticed on entering the room was the aroma of old wood, creosote and oil. In the gloom, I began to make out the source of this aroma. Rows of old railway sleepers were leant against both walls of the long room, the naked joists of the ceiling cast shadows across the old wood and the weak light from suspended bulbs lit the dark valley formed by the eighty leaning beams. Down the valley ran a small railway, with lead trucks placed along the line. The railway led nowhere, and it was obvious that this train would never move again.

It is a necessary thing, this dealing with the materials of a culture and then shaping something new out of it. Hastie does it with enough ambiguity to create a new order, his work is not illustrative but allusive, and, in that, it has an authenticity and maturity to it that belies the fact that the exhibition I saw in Cardiff in 1997 was his BA degree show.

As a student of sculpture in the 1970s, I appropriated the same materials, and had a vague aim to express similar themes. Perhaps I enjoy his work because it succeeds to do what I failed to do at that time. These materials have such a physical presence that it can be difficult to make them into vessels for 'meaning' or 'narrative', they are self-contained. Such materials were once associated with minimalism, certainly when I was a student in the

sculpture department at Howard Gardens the work of Carl Andre (of 'bricks in the Tate' infamy) was an influence. The overwhelming urge was to leave the sleepers of wood which I collected from the beach as found, to exhibit them untouched. The simplistic structures that Hastie builds allow the material to exist simultaneously as unchanged as possible, yet also to signify something else. Hastie succeeds in utilizing these forms as a language for narrative by seeing them as a giant's toy box, full of wooden blocks and rusty Meccano bolts, toy trains and castles.

Works like 'The Keep' (1999) and 'Crossover States' (1998) suggest a world where human life is lived in the shadow of vast forces, structures created by us that now dominate us. His lead castle is dwarfed by the surrounding wooden structure of leaning stairs made from scaffolding planks, at once sheltering and threatening. Perhaps it speaks of the castles of Wales' history, dwarfed by events or protected by our need for these links to heritage. An acknowledged source for one piece is the series of wooden mooring pylons in Cardiff Bay; left there as reminders, they have long since become unofficial 'landmark' objects.

'Sheltered' is a structure inspired by his memory of those absurd 'Protect and Survive' pamphlets distributed by the Ministry of Defence, suggesting that a nuclear holocaust could be survived by squatting under a door leant against a wall of your house. Other works explore the symbolic reference of trains, subject of a recurring dream/nightmare to which the artist is prone.

Hanging on my wall at home, I have one of Hastie's few 'two dimensional' works. The boxed relief (it's not purely two dimensional) hangs above my computer desk, its very real materiality juxtaposing with the intangibility of the computer's workings. It is a piece he made for the exhibition *Darllen Delweddau*[2] in St David's Hall, Cardiff. Almost a working drawing, this untitled piece features elements of Hastie's sculptural works. It is a collage of wood, lead, paper and canvas with elements of 'painting' and mark-making that encourage symbolic reading and yet never let you forget the raw materiality of its making. This is the crux of Hastie's work. Its material reality does not preclude, but actively

encourages a narrative reading, a 'make believe'.

David Hastie is a serious artist, who produces work that can be monumental, but this monumentality is not pompously solemn, it is leavened by wit and humour. Without being an elitist intellectual exercise it yet manages to contain that core of truth about our condition, it evokes, in the words of Raymond Williams, 'structures of feeling'.

What the grant-giving bodies, the powers that make policies for the arts, fail to understand is that without the production of art at the highest level, without artists like David Hastie making work for its own sake there is nothing to aspire to. Without the specialist, the professional who visibly succeeds within the culture, making that culture, and of that culture, what point is there in proclaiming the availability of art as a social or therapeutic pastime, the cure-all social aspirin, 'art for all'? To be a serious practitioner, to be an artist in the true sense of the word, one has to struggle with almost constant financial deficiency. Part-time teaching is many an artist's life-support, but it can also become a vicious circle of earning to support a practice that you have no time to commit to anymore. Another way to survive is by ensuring that part of your art practice at least, can bring in an income. Whether it is possible to demarcate areas within your artform, an earning and an (as yet) non-earning one and keep the right balance becomes a personal issue for each individual artist.

Angharad Pearce Jones (born in Bala, but with family origins in the south Wales valleys, now living in Cardiff) has managed for some years to sustain her career in both demarcated areas, producing wrought iron sculptural objects for offices, winning commissions such as the designing and making of the Cardiff Singer of the World trophy in 1997. In the process it might be said that she gained a media-friendly image – that of 'trendy female blacksmith'. Such a profile must have been of value as a marketing device, in the image-obsessed age an artist needs a new slant, an angle to sell themselves from. As a friend and former flat-mate of singer Cerys Matthews, Jones no doubt would acknowledge the positive publicity garnered from her associations with the

doyenne of Cool Cymru. Yet all of this has its downside. Cool Cymru is ultimately a product of the media and leisure industries. An artist today may need the visibility, but also needs to communicate a deeper sense of purpose and seriousness, one which Angharad Pearce Jones gained from completing an M.A. course in Cardiff in 1999, which has propelled her into more conceptually challenging areas.

Her work has evolved rapidly. At the National Eisteddfod of Wales in Bala, 1997, under the auspices of Cywaith Cymru, she was one of a group of artists from the Penllyn area invited back to create works of art based on the idea of *Gwreiddiau* (Roots). Driving into the town of Bala, or towards the Eisteddfod field, the eye was drawn to the slopes above where an organic, womb and seed-like design seemed woven as it were, into the earth of the hillside. Some people thought it was a new logo designed for the Eisteddfod, and it did, at a distance, possess the catchy simplicity of outline that is both contemporary and archetypal.

At close quarters, the work took on an altogether different aspect. The shapes were made up of singed and smothered grass, sheets of coloured plastic and swathes of dry straw on which had been placed a compendium of rusted, broken and discarded detritus of the farming industry. I say 'discarded', in as much as a farmer discards anything. Jones collected all the materials and objects from the surrounding farms, thus engaging the wider community in a discussion of the work. Standing on the hillside, one felt that these objects had been lined up for assessment, to be numbered and logged or made ready for a sale. This evoked an overwhelming sense of sadness, knowing the fate of many a hill farm in this area. But this collecting of junk and putting it to another use, here as material for art, brings to mind and celebrates the activities of a now deceased resident of these hill farms; Jac Tan y Mynydd. His work appears in Eric Rowan's *Art in Wales*[3], in the form of a photograph taken by Sue Wells. He used to repair his hedges with washing machines and old bikes. Legend has it that one time, knowing that the police were to pay a visit to his farm, he left a metal sheet lying in the middle of his farmyard, with the

words PEIDIWCH 'MELA (a colloquial 'do not disturb') written
on it. From a vantage point in the upper fields he watched the uni-
formed officers cautiously circling the metal sheet as if it concealed
a land-mine, slowly plucking up the courage to lift one corner, to
find nothing but farmyard underneath. Jones was well aware of her
illustrious predecessor, her artwork in Bala held the possibility of
making these connections through a symbol which was about
organic growth, nature and fertility, made from the tools and para-
phernalia left over from the declining farming industry.

At the moment the connection with roots and real-life experi-
ence and history can still be made in rural north Wales. In the
valleys of south Wales, a generation is growing up unaware of the
history that lies shrouded by a thin veil of topsoil, beneath their
very feet. A work exhibited in *Superstructure* at the Centre for
Visual Art in Cardiff in September 1999 consisted of suspended
scaffolding pipes, neatly papered with green flowery flock. 'Llen'
(1999) as she explains, if translated into English, can mean both
veil and curtain. This piece is a scaffolding *llen*. Veiled by the flock
wallpaper it makes connections with the astro-turfing and grass-
ing over of slag heaps and industrial remains that is being done
with obscene haste, leading to a state of collective forgetfulness.
The scaffolding hangs down from the ceiling, limp like a curtain,
although still obviously scaffolding it no longer serves a utilitar-
ian purpose.

There is an irony inherent in Jones' most recent work; it forms a
full circle with her image as the artist blacksmith, a traditional
worker. She realizes the way in which manual work of this kind has
been relegated to the realm of the DIY enthusiast, white-collar
workers becoming blue-collar weekenders. In one instance she has
presented her own anvil, prettified by a shiny coat, as an ornamen-
tal object. Tools are subjected to a process of gentrification echoing
that of traditionally working-class areas like Cardiff and Swansea
docks. The nickel-plated anvil (seen as an act akin to sacrilege, and
causing great consternation among viewers) is a metaphor for the
marina mentality of the developers as much as it is a reflection of
the all-pervasive heritage industry. A wood saw with broken teeth,

covered with embossed foil is hung on the wall, a surrogate for those trophies and ornamental ironwork she has been commissioned to make for the new offices of the media industry. The tools of a trade now become ornaments.

In a recent talk with her, she expressed concerns that the closure of the Rover manufacturing plant would lead to huge redundancies in Port Talbot steelworks: "these things are happening now; it's not just about the past". She sees 'heritage' as a con, a cynical exercise in exchanging real experience, real work and real life for a fake and romantic 'leisure experience'.

In an installation at Chapter Arts Centre, for the *Fresh* exhibition in 2002, Jones built a structure that incorporated elements from her earlier works, making, with the title 'Just what is it that makes today's workplace so different, so appealing...?', a punning evocation of Richard Hamilton's 1956 Pop Art classic, 'Just what is it that makes today's homes so different, so appealing...?'. The incorporation of a large image of a topless model begs the question whether sexism has vanished with the old industries or whether it still lurks in our new, 'clean' workplaces, if in a less visible manner.

Both David Hastie and Angharad Pearce Jones are artists who connect and deal with the current culture in Wales. Both use the materials of the superseded culture and transform them, replicating the regenerative impulses that are rife in Wales at the moment whilst also providing an incisive critique of those forces. Their work exemplifies the notion that art is a product of a culture in conversation with itself. The products of these young artists give us an asset that we would have done well to celebrate in The Year of the Artist.

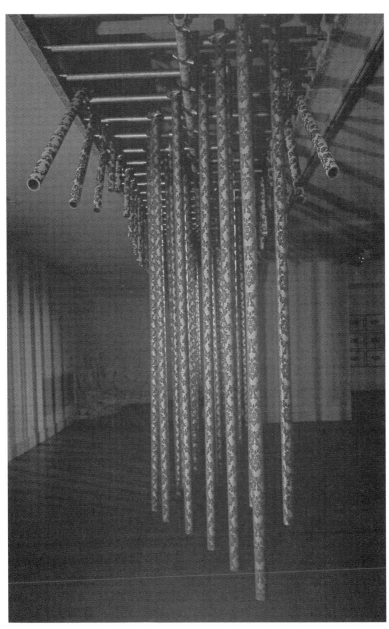

Angharad Pearce Jones 'Llen' (1999) scaffold tubes, flock wallpaper, 300x100x500cm

Angharad Pearce Jones 'Just what is it that makes today's workplace so different, so appealing...?' (2002) mixed media, dimensions variable

Sue Williams 'Move 1 (Taste the Pleasure)' (2002)
charcoal on paper, 120x90cm

Sue Williams 'Collaborations' (2003) mixed media, 150x150cm

2.3

ALL HERS!
COMMUNICATIONS WITH SUE WILLIAMS

Friendships were not easy to nurture in the Forces ... every home was short term.

The words are Sue Williams's, winner of the Gold Medal in Fine Art at the National Eisteddfod of Wales in 2000. An artist with whom, as reported in the *Western Mail*, I share a studio. Not quite, but we do have studios in the same building in Bute Street, Cardiff, along with seventeen other artists, including Phil Nichol, the medal-winner in 2001. We have more than the occasional conversation about art and the world outside the studio where the work ultimately has to exist. In Sue's studio the paintings always loom in the background, changing rapidly. A painting seen two days before has magically 'morphed' into a different, new paint-ing. In talk we touch the surface of the work, the material considerations; "What did you use to attach that canvas patch?" "Was that thick area of paint deliberate?" "Is that a heart, or are they a pair of lips?" This essay is a record of 'communications' that attempt to delve deeper into the origins of her work, work that she has referred to as "an analytical biography, a visual monologue" and "a portrayal of unresolved thoughts".

She had been brought up in a close-knit family; they depended on each other for support.

In the last eighteen months or so I have got to know Sue Williams' work more intimately as a fellow member of both the Butetown Artists Studios and the Ysbryd/Spirit Wales group of painters. It has become more direct, as if suddenly she had discovered a use for her visual vocabulary. This language consists in drawing directly onto large canvasses, rapidly and unpremeditated, with a

high degree of natural and fluid draughtsmanship. Colours are laid as a base, lines are drawn, washes added, errors lead to erasure, the addition of more colour, which in turn necessitates more change; figures appear, the balance of the composition changes. Words, sentences, jostle with the freely drawn and floating images. The canvas ground is a flat yet infinite empty space behind the drawing. The mixing of drawing styles suggests that this might be the work of more than one artist, like graffiti, added to over time. Parts would elicit approval from the most solid Academician, others are deliberately crude.

At thirteen she should have known better.

The word 'drawing' more than the word 'painting' seems relevant to these canvases. There has always been a tendency to see drawing as a preparatory act, not finished work. Yet working drawings are often more vibrant and alive than the final, painted versions.

SW: *I remember some time ago being introduced by a certain arts administrator as "the painter who does not colour in". A comment that led me to question the meaning of drawing, and in turn to make a conscious effort to bring about a certain relationship between drawing and painting. Drawing is a medium that enables me to extract ideas/images from my mind at a rapid pace. It also offers me the freedom to improvise and re-invent – providing me with a more immediate vehicle with which to respond. The images are part of a serial event moving towards a desired state, human emotions, body language and signs are interpreted through action. Drawing is greatly undervalued today and should be given a higher profile throughout art training. Within the last couple of years I have been invited to assist on an investigative Drawing Module on the Fine Art Course in UWIC – vital!*

Drama is created by the interplay of figures, some which seem drawn from life, some symbolic or graffiti-like. In past work, the figures inhabited a sombre landscape, were more carefully drawn, their existence more melancholy somehow. Now they are in a world of agitated neon candyfloss colours. This new energy and sense of direction seemed vindicated by her success at the Eisteddfod.

all hers!

SW *Prior to winning the Eisteddfod Gold Medal, I had won the Rootstein Hopkins Painting Award. Receiving both awards gave me an enormous burst of energy, the scale of the work grew with the confidence. I feel positive about the direction my work is taking. Winning the Eisteddfod has also led to the purchase of work by the National Assembly. It is not a matter of "I've done it". I would not wish to feel satisfied, not by any stretch of the imagination. This is only the beginning.*

She thought he was a friend ... she trusted him.

There is a renowned artist also called Sue Williams based in New York, her work deals head on with gender issues, male preoccupations with women as sexual objects. Her graphic drawings in paint are sexually explicit, cartoon-like images. 'Our' Sue Williams, and I can say that because though born in Cornwall she has lived in Cardiff since 1976, also writes words, slogans into her paintings. Of the 40,000 or so visitors to the Eisteddfod Arts and Crafts Pavilion, some undoubtedly agreed with Clive Betts' view (there are always a few), that the work is thinly-disguised pornography. The twist, we may surmise, must be that a woman makes it. People seemed surprised by that fact.

She must have flaunted herself. A temptress at thirteen it was said.

Artists have explored the world of sexuality and gender, of feminist critique since the 1970s. It is therefore not a case of labouring a point to compare Sue Williams' work to that of her North American namesake, if only to draw out the differences. Because, despite a superficial connection that can be made stylistically or based on content, 'our' Sue Williams' work does not rely on heavily loaded arguments. Whereas the American points an accusatory finger at men as the cause of sexual alienation, in Sue Williams' work there seems to be a questioning of stereotypes of femininity and of feminism as set up by women themselves, or at least as accepted by them from the media and fashion world.

How did he kiss you? they asked her.

The work is more an exploration of personal identity than a sermon. Her work is ambiguous, not didactic, and yet it still manages to make us aware of the unconscious patterns of behaviour that are continually foisted upon women by cultural habit.

SW: *I am a woman making self-reflective work, this naturally leads to its categorisation as feminist art, though I have not tried to define my practice in that context. I am fully aware that my work has 'touched' sensitive areas and has in recent exhibitions caused a particular response from other women over the concerns of female vulnerability – this has not been a conscious decision on my part, I am merely taking the time to work out my own vision. My work partly focuses on my own vulnerability, and at this time it has to be said, 'as a woman'. As my work evolves the more conscious I am that what I am saying is fundamental to the issues of feminist critique. I am at a very interesting stage in my life, which many women in their forties might relate to very strongly. I am who I am, and through my work I am endeavouring to find even more answers.*

She wore a bikini (with an inch of midriff showing) ... she asked for it.

Earlier work was concerned with domestic preoccupations, a child's toys, prams, interiors, the paraphernalia of life as a single mother; the work has now turned away from the representation of real things, real lived experience and turned inwards and outwards also, into a postmodern chaos of poses and attitudes usually confined to the pages of men's magazines, and obviously (in some cases) emanating from the depths of the artist's memory. As one 'reads' the surfaces of the work, now getting bigger and bigger – a work shown at *Avesta 2000* in Sweden measured twelve square feet – one becomes uncomfortably aware of the conflicts involved in the action and in how the viewer, particularly the male viewer should respond.

all hers!

Did his tongue go inside your mouth? they asked her.

There are young girls flaunting themselves, mature women display ample buttocks, there are no men. Guiltlessly, the male gaze is invited. These appear 'cheeky' rather than obscene images. The more one looks, the less the work seems directed at the viewer – they are certainly not for our titillation – and the more they begin to resemble a diary. A confusing set of events and emotions is being presented, dare we read more, dare we ask more? A private world has somehow escaped, larger than life, into the public domain. Is there a traumatic event being dredged up from the memory, partly hidden by the light-hearted appearance of the poses, the cheerful colours, the appearance almost of Edwardian erotica? There are intimations of this in the work, darker overtones.

He said he loved her and would leave his wife for her. At thirteen.

There was a cautiousness about Sue's written replies to these communications, she was wary of putting things into words lest the paintings lost their magic; they are the expressive field where she feels happiest dealing with her memories, and yet the paintings have released her from the bottling up of these memories. At thirteen she fell prey to an older man who befriended her and then destroyed her world of innocence. There was a court martial; accusations levelled at her, cross-examinations, consequences, effects on her family. Now, more than ever, as we are questioning the world of twisted male desires – how men can actually believe they are being 'led on' by children – her work, dealing with her own trauma, is all the more relevant.

SW: *As a child I used to write in the type of diary that had a lock and key. Hide away thoughts and actions. My father was in the RAF, I grew up in the Forces, twenty-three home moves, Bahrain, Cyprus, the Lebanon, all over the UK. Friendship did not come easy, potential friends knew we would be leaving shortly. I had no control or understanding of the nature of sexual power. The words that come to mind, apart from vulnerability, are sexual awareness, sexual control, provocation, encouragement, naivety, punishment, guilt. My paintings are*

all hers!

my diaries, a visual interpretation of the diary. Through the visual image, words included, I relate to personal experiences and thoughts and in doing so I also connect to broader 'political' comment.

She came face to face with her own vulnerability, her innocence.

SW: *Each canvas is a page in my diary where I allow myself the opportunity to re-invent memory, play with images, deal with issues and more importantly, deal with my own vulnerability and femininity.*

It has been argued for some time, that paintings no longer represent reality – that function was ceded to other media like photography, television, and video or computer simulation long ago. 'Handmade' paintings like these retain the visual surface that is the mark of all things visible, but they have ceased to refer to a reality outside of painting. In a way, even 'figurative' painting is abstract now. It has a specific character of reality that is all its own. It is not an illusion or a depiction of a kind of reality, or a view of the real world. A painting becomes the fiction of an artistic existence and every exhibition a contribution to this fiction. Although paintings are commodities, marketable products on the one hand, the fiction of the artistic existence is also very much the work of intellectual processes and decisions on the part of the participants. From the conventional point of view then, Sue Williams' works may look distorted and fragmented, assembled from individual set pieces and quotations. In fact, they form a unified whole, a wholeness which is still very much a representation of the world, of this woman's world, as she has said...

All hers!

Sue Williams 'Brides on top of it all' (2003) mixed media on canvas, 180x180cm

2.4
NAMING THINGS:
NEALE HOWELLS AND ELFYN LEWIS

To get exhibitions outside one's own square mile, it helps if you can prove that you are appreciated back home. You need to show articles, pieces of critical writing, reviews, catalogues of exhibitions. If Wales is your square mile, it is very difficult to provide this evidence; you cannot naturally 'grow outwards' into the wider world because you have not made a visible mark at home. There is no art criticism in the national paper of Wales, very little serious handling of the arts on television and no dedicated magazine covering the visual arts. Therefore there is no fostering of writers on art. Wales' best known writer on visual culture, by his own admission, finds little of value in the contemporary scene. Wales' best known artist decries the poverty of contemporary art in Wales. Artists, in desperation, turn to computer keyboards themselves, as is proved in the magazine *Planet*. This essay highlights the work of two committed artists, both on the cusp of this 'growing outwards', who need more introduction to the home audience, and a response by home writers to their work.

It could be argued that in today's art world, an artist is not fully operative until such a process of dissemination has occurred. We dwell in a world where works of art seldom stand on their own. They need to be seen in a context, which, if not given by the academic world, or the high art world of galleries and critics, may be sought or acquired from the world of hype, transient fashion and pop. It is here that some art historians stumble when commenting on contemporary art; they find only hype, and compare this to the presumed honesty of those past masters, toiling at their well-honed craft with skill and dedication. Artists in those days could draw, we hear them grumble. Of course, hype with no talent is a cause for concern, but it is makes no sense to cite it when making qualitative

judgment on an individual artists' work. It does not change the fact that artists work with that which is available, as they always have done. Methods change, the emphasis changes, the instruments and materials change, as do the requisite skills. In a crowded art scene there is stiff competition, artists need to distinguish themselves from others and publicity is one means by which to achieve this. PR is one of the necessary skills for an artist today.

Two painters (a salutary fact in itself, painting having been posted D.O.A. in an expanded field, where art can equally be an event; a spectacle rather than an object) Neale Howells and Elfyn Lewis have experience of associative attention coming from participation in the world of rock'n'roll. For Lewis this is something that happened in the past, something that tends to distract attention from his current work. For Howells, this is a new phenomenon. The thing that is of most interest here however is that they have both done this within Wales' particular Cool Cymru scene, and that both share (though one might deny it) an authenticity that is culturally specific in its nature.

Elfyn Lewis was born and raised in Porthmadog, in the very heart of the north Wales landscape made familiar by painters from Richard Wilson and Turner to Kyffin Williams. His art master at school, Rob Piercy, has since carved a niche for himself in this same genre. It may help to know that Lewis is colour blind, it may not. He was encouraged at school to believe that the sky does not necessarily have to be blue, and that the sea could be red. This liberating tenet has stayed with him ever since, as has his need to paint his home landscape.

This landscape is a starting point for him, both biographically and as source material for his paintings. Up until today, it is this very specific landscape, indeed the view from his childhood bedroom window that has nailed itself into his imagination. His parents house is at the entrance to the town, at the end of the cob, (the road and rail-carrying sea wall built by the town's founder, Maddocks). His window in the tall house overlooks the river Glaslyn as it wends its way into the estuary, the mountains above Harlech beyond. Beyond that, the open sea which took many of

Elfyn Lewis 'Pen y Bigil' (2002) acrylic on paper, 75x75cm

his forebears out into the vastness of the world, and brought stories and souvenirs back. Porthmadog, nestling in that armpit hollow at the north of Cardigan bay, the Cnicht and Moelwyn towering behind and Moel y Gest sheltering it from the sea winds, has always been a place open to the world. Built as a port for slate export, its men have never been insular; perhaps that seafaring tradition goes back into the age when the Irish Sea was a trading route of much greater significance.

After a productive time spent on the foundation course in Bangor, Lewis moved to Preston to do his degree. These years were not his happiest; he found discrimination and a lack of empathy for his work, which was willfully becoming more and more politicized. He was asked to take a year out. How often has this been the story for students from Wales in English colleges of art who experience an unwillingness to see a different cultural identity and different needs of expression? Moving back to Wales, he settled in Cardiff in 1994, rejoining his Bangor compatriots who were also moving back to Wales' capital from various BA courses in England. They included Gruff Rhys of Super Furry Animals, and the sculptor Angharad Pearce Jones, whom he assisted with large-scale works. He lived in a shared house with, amongst others, Cerys of Catatonia. It was natural to team up and work together, share ideas. Altogether Lewis made covers for five singles and the album *Way Beyond Blue* for Catatonia and another three CD covers for Big Leaves, including the album *Pwy sy'n Galw?*. This was the period when his strangely fragmented heads, portraits broken into segments like a Schnabel fractured-plate painting became a signature. At this time, he also designed book covers for Parthian Books. This was jobbing work, he did not make a fortune, Catatonia was still up-and-coming rather than an established band. Through this work, however, and his association with other artists in Cardiff, he began regaining the confidence lost at Preston, and decided to test himself on an MA course at Cardiff College of Art in 1996.

Lewis's work became more abstract. He was driven by the question "am I, or am I not a painter?", and unlike many who

embark on the MA course and move to video, photography or installation, Lewis decided that he was indeed a painter. But how could he claim his particular piece of ground, his niche in this overcrowded field? He moved away from the expressionist style of his figurative work and began to employ a process-based means of painting; dragging swathes of primary paint across the surface of canvas and paper, encouraging accident and inviting – conjuring – forms to appear. Abstraction in painting has taken on the appearance of several art movements, not purely formal: surrealism, expressionism, minimalism, even pop, but traditional landscape is an idiom most readily affixed onto an abstract canvas by the bewildered viewer. It is easy to see the contours of a 'view through the window' as soon as anything resembling a horizon line appears, a suggestion of clouds and mountains register through the eye to the brain, which immediately tries to make pictorial sense of the image. Like gazing into the flames of a fire, abstract shapes become trees and lakes. Where the viewer is unaccustomed to reading an abstract image as pure colour, pure form, (and this is particularly true in Wales) long discussions are held on each interpretation of what the picture is about, what it is recognizably about. Lewis's paintings seem to make an ironic comment on this habit, in that they can be viewed as both abstract and figurative. Some, more than others, suggest a layered account of that landscape viewed through a window from the artist's childhood home. The horizon appears multiplied, as if two prints of the same picture were overlaid. Other paintings become less representational, the landscape 'hidden' from view, pure flows of colour dragged across the surface with his favoured implement, the cassette tape case. He works prodigiously, since accident and overlays are part of the process, much work, perhaps ninety per cent is discarded. The working process is that of the controlled accident: "90% process, 9% skill, 1% luck, but the 1% luck is what you are looking for" says the artist.

Added to the pictorial suggestion of landscape, the paintings are given evocative titles, not ones that refer to the work as formal abstractions, such as 'red on blue with green'; "The naming of

things is important," he says. The paintings are invested with memory, feeling, ideas of belonging and place through a careful process of naming. Titles of a series of recent works is 'Purgad', the name of a friend's farm, whose family has lived there for several generations, but are now faced with eviction as the landowner is selling the farm at a price they cannot afford. Naming of this kind denotes tribute or memorial. Sometimes titles are more ambiguous and abstract, concepts like surname, tourism, nicknames, voice, knowledge, soul and people, lists of ideas seemingly unrelated to individual paintings, or interchangeable within an exhibition. These titles refer to a cultural context normally outside the parameters of such abstract work.

Siân Hughes writes in a catalogue to one exhibition:

> His paintings are often a comment on the accidental nature of beauty. His method is to experiment with line and colour until something beautiful and true begins to assert itself, reflecting the accidental way in which the landscape, and life itself, has evolved.

Why do we accept the notion that a view of sea and mountain is 'beautiful'? Is it form, colour or invested knowledge and deep memory that do this? Does going away and coming back intensify the feelings of seeing the landscape of home? How many different ways do we relate to colour? Lewis's work takes all these elements together and reshapes them into new configurations. These new configurations are paintings, each unique, each related, and each self-sufficient. Recent paintings prove his work is, above all, about paint. 'Landscape' is a by-product, conjured from the resulting patterns of the paint and from the artist's concern to locate himself within his own cultural heritage.

Neale Howells comes from Neath, a different Wales altogether. He studied at Bath College of Higher Education, from whence he returned to Neath, making excursions to New York, Sweden and Berlin. Visiting the artist at his home brings to mind a visit to an artists' home in Africa. The yard, the shed, the kitchen, all provide surfaces for painting. He paints tables, or rather constructs tables out of paintings, which in turn are made on discarded planks of

wood. There seems no boundary between art and life, and art for Neale is a straightforward engagement with his craft, a physical activity rather than an intellectual deconstruction.

Howells paints on wood, canvas, hardboard, using household paints, as inveterate a recycler as any African artist. At first you might assume that anger drives him, but maybe it is joy, and, perhaps more surprisingly, an odd whimsicality. He follows the Arte Povera dictum, using only found materials, or perhaps he follows no dictum at all. Paintings come in all shapes and sizes, sometimes made up like conventional triptychs, sometimes odd-ments of shapes attached to each other. The work is bold, graffiti and cartoon-like, yet highly individual and painterly in the sense that each painting is built seemingly at random into highly sustained compositions of colour and form. He sees each work as a complete painting, not episodic and fragmented snippets collaged together

Referring to his post-Berlin paintings of 1996 he says:

> In creating these works I try to make them as uncontrived as possible. Using the process of creating and destroying I hope the work will read further and become more direct. If an image becomes assuming then it is simply destroyed.

The artist dislikes comparisons made with graffiti: "Graffiti is better" is a typical self-deprecating remark. Essentially abstract, (another word he questions: "how can anything be abstract?") they have daubed figure drawings on top of the paint, sometimes weird buildings emerge, in particular the paintings made after Berlin. Scribbled writing; slogans, profanities appear; made-up truisms emanating from some post-industrial hell, dysfunctional yet darkly humorous ... "me and the family going to kill ourselves". There is an irreverently anarchic disregard for convention (until this in itself becomes a convention, of course), less political sloganeering, more jumbled rantings from the edge of society. But that does not make this artist's work meaningless. There is a grass-roots polemic here, though he refuses to be a voice for anyone except himself. At thirty-six Howells says he cannot represent the

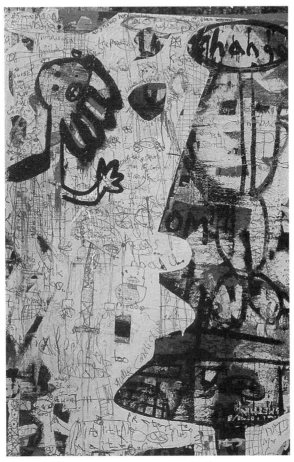

Neale Howells 'dip cuss nut' (2001)
acrylic, oil, pastel pencil on board, 120x150cm

concerns of youth, but his talk reveals an attachment to place as real as Lewis's. We can well imagine where this place might be; a generic inner city or a by-passed post-industrial valleys town pretending to be Berlin, or New York.

He returned home to work because there were plenty of disused factories and hospitals to work in. He felt this place had, "All I needed to make my paintings in" and that a stand had to be made to halt the exodus of artists out of Wales. Out of his vast output, four small works perhaps reveal his 'political' concerns. They are called 'Museum of contemporary art for Wales' and are fairly realistic depictions of the disused cooling towers at BP, Baglan. One has the towers morphing into a vast silhouette teddy bear that he feels, with half a smile, could make an outstanding contemporary art gallery and landmark building in Wales.

If this is living history, it is also inescapably locked into recent art history; Basquiat, Dubuffet, Asgern Jorn, the Cobra Group, (taking its name from Copenhagen-Brussels-Amsterdam). It has been said that history either stifles or creates new opportunities and Howells's awareness of past art does not devalue his personal and particular expression, one that I believe is as specific to location as is the landscape of north Wales to many artists there. Ed Thomas' *House of America* is located in this same area, and shares a certain claustrophobic expressionistic texture.

Titles, as in Lewis' work, are important, but in a different way. Here the naming of paintings serves to complement the street level aura of the work; 'The last erection of Christ', 'balls to Picasso', 'evolution of fuck'. He brings the street into the pristine gallery, there is a frisson created: would you let your kids out onto these streets? Yet don't you want to buy that painting and have it on your wall? Titles are sometimes random thoughts or snatches of song that come into the artist's mind as he paints. Often they refer to the painting as reminders for the artist of which painting he is talking about, they are named after completion such as 'Little boy's drawing nicked by me', describing a painting which contains a childlike drawing of a standing human figure. Stick-like humanoids have become a feature of recent work such as

'Pleasant shit' (2001), which the artist believes is helping the viewer and the artist himself to understand the painting.

Is there a deliberation to Howells's actions? He famously seems to court controversy, negative publicity becomes positive. Exhibitions are cancelled (Oriel 31 in Newtown), sensibilities are offended, (the National Eisteddfod's audience) council officials and police tear down a painted hoarding (in Cardiff), old ladies and horses are frightened. All is reported in the *Echo* and *The Western Mail*.

Yet somehow, this naif, *enfant terrible* stance is not altogether convincing; the man is too astute. He succeeds in selling work to a broad audience, and he has utilized the Arts Council system of support. He exhibits regularly and widely, recently holding a solo exhibition in a large London gallery, showing at art fairs, at the Tabernacl, Machynlleth, and is well represented by the Washington Gallery in Penarth. It has become legend now, how Nicky Wire of the Manic Street Preachers left a gallery with some of Howells's paintings under his arm, how Sony were persuaded to buy and use his work for the Manics' CD, *Know Your Enemy*. It is too soon to tell whether this adds value to his work or leads to further exposure; it has been a point of interest; "people really want to talk about that". In a world of marketing artists with one-line sound-bites, it's not a bad one to have. The Manics have a certain credibility, enhanced by their concert to launch the album in Havana, in the presence of Fidel Castro.

Neale Howells has achieved a recognizable style, a format that is his, and so has Elfyn Lewis. Both artists are aware of the problems of being identified by a particular look, both know what happened to Jackson Pollock when he failed to move on from his famous drip painting, or Rothko when he took his paintings to a place where he could go no further, when hype overshadows an artist's work, as with Basquiat. Frustration and self-knowledge kills. Being an artist is to live dangerously with these possibilities, to take risks, never to be satisfied. Talk about the art of the past if you like, creativity happens in the present.

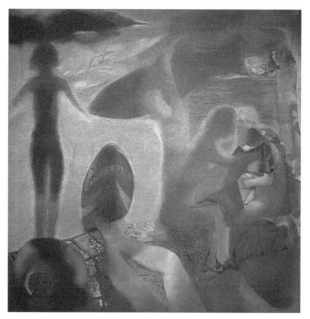

John Selway 'Spanish Gothic 4' (2001) oil in canvas, 55x55cm

2.5
JOHN SELWAY, PAINTER

As more and more of us connect up to the internet on a daily basis, we are getting used to looking at images at a rate that would once have been thought of as an overload of visual information. Windows on top of windows, text on top of text and image on top of image is the norm. It seems likely that we will expect all images to approximate this state, as book and magazine design is already proving. Do paintings offer us windows onto and into a world of inner thought in a similar way? Looking at John Selway's multi-viewpoint works, we are faced with a welter of information that emanates from the artist's imagination. What is real and what is imagined?

Painters have occupied a special place in the arena of illusion, reality and imagination. John Selway is a painter in the sense that Picasso used the term when describing himself, no matter whether he worked with montage, ceramics, sculpture or assemblages, he was still a 'painter', never a sculptor nor even an artist. This would suggest that the term encapsulates more than just the act of a person laying paint on canvas; it includes the imaginative and tactile sensibility that a painter employs in all his encounters with the world, which dare I say it, is not as narrowly directed as that of a sculptor whose processes traditionally demand laborious and intensive activity, more narrowly focused, and more constrained by pragmatic concerns. 'Painting' for Picasso was a special, almost sacred occupation. His painting was the thing that connected him to all the painters who had ever been, an elevated breed, shamanistic magicians, inventors, outsiders from normal society and free of its constraints, yet crucial as healers of that society.

He used the word 'painting' because he didn't ever use the word

113

'art' any more than he did 'beauty'. Painting had captured religion and, in prehistory, 'whatever it was, we don't know'. Picasso was satisfied by the certainty that, like the cave painters, he had captured something... Painting was to bring up, from the depths of the unknown, all that is so alien to man that he is unaware of it, but close enough to him so that he can recognize it.[1]

Contemporary artists have succeeded in freeing themselves from narrowly concentrated skills, able to hire specialists to make objects for them, so that they can be released into a world of imaginative invention untroubled by pragmatic considerations of whether they themselves can make the stuff they dream about. This is close to Picasso's idea of a 'painter', but I think he also saw the act of translating idea into form, through the physical action of mark making, as a necessary component of the 'magic'. Painters 'think' through paint, a painting is more than an object, it is an accumulation of thought and action, often of erasures and additions, repeated ideas and new discoveries fight it out. It is a train of thought made manifest. Henry Miller, the much maligned author of *Tropic of Capricorn* who rediscovered a joy of life through painting said "to paint is to love again". For truly dedicated painters all emotions, not just love, are thought through in paint.

At the moment it might seem as if the painter's role has become increasingly compromised. Young painters feel they have to adapt tactical poses to compete with 'new media' such as video and installation. This perceived lack of contemporary relevance in the face of challenges made by other media is not a new phenomenon, and painting has met the challenge before. This time around, some painters have gone in for gigantism, wresting attention by scale, paintings as installation pieces. The trend for building large exhibition spaces dwarfs anything less. The Argentinean painter Fabian Marcaccio makes free-standing paintings that reach lengths of twenty metres, creating false walls of pigment-encrusted canvas supported by armatures of metal pipe and bungee cords. He uses a computer to manipulate scanned images of political signs, advertising logos, photographs of small sculptures and drawings that he has created. These are

printed onto a 'plasticised' form of canvas using a large-scale plotter. Direct painting and the layering of silicon gel then further add to these printed collages. He himself directs our attention to his stimulus:

> Right now the world itself is a disparate collage, and communication technologies have made it possible for international industries to produce collaged products, by utilizing workers, materials and means of production in many different countries, without respecting any provisional local orders, at will. Our generation is perhaps the first one to try to integrate or organise something after this now established all-over cultural collage.[2]

Whilst John Selway eschews the high-tech tactics and bombast of an artist like Marcaccio, there are surprising similarities between their work. The collaging of images is one of them, as is a system of 'printing' onto the canvas. Whilst Marcaccio uses technology, Selway does the processing in his head, and 'prints' drawings onto the canvas by hand, transferring drawings from tracing paper onto the painting's surface. The wide scope of subject matter that Selway has approached from the hybridity of Pop Art influence of London in the sixties, via immersion in subjects like the Holocaust, up to the Dylan Thomas 'readings' of the present, reproduces the effect of the 'all-over cultural collage' that is today's world. Working mainly in a traditional format, sizes no more than four feet by six feet, he still expects the viewer to enter the work, rather than the work to physically enter the viewer's environment. Likewise, he does not resort to evident physical mark making; these paintings encourage the viewer to look at them not as physical things, but as windows into another dimension.

Quite often, the dimension we enter is a personal one, but the key to gain entry comes through other stimulus, such as the poem 'Fern Hill' by Dylan Thomas. The paintings that relate to this poem are in no way illustrations. Selway has created parallel poetic constructs, drawing from his own memories of youth. The poet Mererid Hopwood talks of the verdant greenery of Selway's works seen at a recent exhibition in St Clears, west Wales, greenery that suggests to her a particularly 'Welsh' depth of

understanding of the poetry of Dylan Thomas. This is an inter-
esting statement, since it suggests that there is a 'Welsh' way of
understanding as opposed to any other way, English or American
perhaps. A 'Welsh' perception is usually taken to mean the kind
of poetic reading of things that is held to be common amongst
speakers of the language. Whilst this is something I know to be
true amongst some Welsh speakers, Mererid Hopwood being a
case in point, it is usually explained by linguistic difference. A dif-
ferent cultural imagination is shaped by centuries of thinking
within language; it is a compliment to recognize that element in
the work of a non-Welsh speaker. Incidentally, similar cultural
reasons mean there is no proper Welsh word for 'painter', or for
'drawing'. Visual thinking turned to the written word could as
easily have been turned to paint. If only we had a word for it!

Poets respond well to Selway's work, his imagination has paral-
lels with that of the poet and he constructs his narratives as a poet
would. It is not only the visual world, but also the inner world of
thought that is touched upon, and that, by being made visible, is
brought closer to us. Selway takes subject matter and improvises
with it, interprets information in a certain way, and re-presents it
as a self-contained object. The poet Tony Curtis believes him to
be "one of the more literate painters in Wales. His wit is often lan-
guage based, visual puns abound".

He is also what you would call a very down-to-earth man.
Someone in a pub asks what he does and he will answer truth-
fully, hoping it will be misconstrued, so he can happily spend the
rest of the afternoon recounting tales of house painting. It's easier
that way, less explaining to do. With his leather jacket, chunky
fingers adorned with even chunkier rings, he is not the epitome
of the sensitive aesthete, and indeed it would not be a surprise to
find a house painter's van parked outside. It's hard to imagine
that this is the man who paints so lyrically, so precisely, and with
such subtle colouration.

John Selway was born in Askern, Yorkshire in 1938, but moved
to Wales as a child when his parents returned to their hometown
of Abertillery where he still lives. He studied at the Royal College

of Art in London from 1959 to 1962 and the University of London until 1963 at which time he won the Boise scholarship, which allowed him a year of painting in Portugal. From 1964 to 1991 he lectured at Newport College of Art. His early years in the London of the 1960s obviously meant that he came into contact with artists and the scene that surrounds Pop Art in its British manifestation. He was a contemporary of Hockney and benefited from the teaching of the famous American abstract artist, Rothko, a visiting lecturer. That an abstract sensibility underpins his work comes as no surprise, the arrangement of forms and spaces in his compositions exist independently of the narrative and gives structural support to the poetic fluidity of the figurative element that is apparent when seeing the work.

He maintained contact with this scene after his return to Wales, exhibiting in 1967 with the best of British Painters at Sao Paolo's Museum of Modern Art in Brazil, and continued to appear in prestigious group and solo exhibitions throughout the 70s, including several organized by the Welsh Arts Council and by the British Council. Had he been more London-centric he would undoubtedly have enjoyed a high-profile career, but his heart was in Wales, and perhaps he was not suited to the social milieu. He has always been a traveller, and he has 'studied the human spirit', his own included, in places as diverse as the USA and the Soviet Union, and briefly, living with a circus troupe in Italy. Back home, he joined Group 56 Wales for a period, exhibited widely as a solo artist; he is now a member of the Ysbryd/Spirit group of Welsh painters, who have had exhibitions in London and in France.

An apparent moment of epiphany overtook him a few years back, which led to a career self-evaluation. He felt that his canvases had become overburdened with paint. All the paintings that he could lay his hands on from that particular period were burnt. The only survivors were either sold beforehand or happened to be out of reach at exhibitions or in gallery storage – he now professes relief that he didn't get to all of them.

In a conviction echoing numerous painters, he finds the paintings he 'likes' at the time of making are the ones that ultimately fail

to satisfy him. He will often destroy them by painting over them. He goes through periods where he chooses subjects that are problematic, and therefore not as likely perhaps to result in work that can be 'liked' easily. The war in Sierra Leone as witnessed on TV documentaries and news items, gave rise to a painting like 'Snake the Invisible Warrior'. Characters appear out of Bertolucci films or novels like Ballard's *Cocaine Nights*. A painting that won the University of Glamorgan Purchase Prize in 1996, 'The Day of Purim' is an evocation of the Holocaust. In a statement by Selway in the catalogue to the exhibition that launched the Ysbryd/Spirit group in 1998, he says that his work attempts to

> deal with the world in a way that involves an imaginative reworking of the facts. The paintings are not in any sense a duplication of the experience of these facts, but the extension of the original experience in a way that mixes that experience with other sources into a system of imaginative and formal inventions.

What he is doing, then, is literally creating a new reality out of what passes to be 'facts' and what he knows to be 'memories'. The painting reproduced alongside above this statement, 'The Day of Purim. Grey Vans Koidanov Forest. No2' to give it its full title, is difficult to decipher at first glance, since it is not a record of a real event or a real place. On staring 'into' it, one begins to sense that it is a real and disturbing glimpse of an event that happened. Though it is in no way photographic, it becomes like a shot of a scenario in a dream.

Of the artists he came across in those heady early years of the 60s, an alumnus of the Royal College at the same time, R.B. Kitaj seems the closest in spirit, and this painting for several reasons reminds one of that. A charismatic American, older than the other students, who had travelled the world as a merchant seaman, Kitaj is credited with introducing Pop Art to London. There is a similar deliberate awkwardness in the poses struck by the figures in both Selway and Kitaj, poses that emphasize the weight that events taking place are having on these personages. One might say that these figures were actors, taking on roles, and

that if you look closely you might recognise them appearing as different characters in 'films' by other people: George Grosz, Otto Dix, Beckman and Balthus, even Francis Bacon from the twentieth century. But his talk is more liberally peppered with allusions to Florentine art. Art history is a bountiful source that he knows well and he has the painter's intelligence to appropriate constructively without it ever marring his own style.

The quality of light, colour and surface in his work is unique to John Selway; the less obviously portentous narratives are also his. Families on the beach, women out enjoying themselves in 'Hen Night Karaoke', these are ordinary, day to day scenes lifted almost by the magic of cinema, so that they appear as if on a luminous screen in the darkness. Cinema, in particular European cinema, has been a great love of Selway's as well. There is a casual eroticism (the type you don't get in Hollywood) in the paintings of men and women together, which is as much suggested by the silkiness of the paint as the semi-transparency of the women's attire, or the drunkenly exposed breasts of the hen night crowd. 'Café Azul' (2001) has a lovely scene played out in what might be a central panel of a triptych, a nonchalant but supremely enticing pose is struck by a woman drying her hair, legs akimbo in front of a man who is sitting, staring at her midriff. It captures the way that women profess to be baffled by the appeal they hold for men in those moments of ordinary actions, and the guilt men feel for having such ungovernable thoughts. We don't know, either, if the man is husband, uncle, or stranger. It's an everyday beach scene on the one hand, yet it has an orientalist opulence and allusions drawn from art history on the other.

The paintings, as ever, are a play of light and shadow, illumi-nated from within, as Osi Rhys Osmond comments in his essay on the artist published in *Planet* 147. He uses this light to reveal set pieces within the picture frame, the way sun streams into an attic space in 'Swallow Thronged Loft' for instance, and lights up a scene of adolescence. Blindfolded, a boy reaches out to try and catch a hold of the girls who sit around him, all this bathed in light, and we view the scene through the same hole in the roof

that allows sunlight to enter. There is a ladder in the picture, as there is in several others, but my attempt to construct a symbolic meaning around this object is resisted by Selway. "How else would they get up to the attic?" is his reply.

Selway's method of working has similarities to that of a print-maker, a skill that he teaches, so that stages are employed in the layering of image and colour, from the back to the front. Drawings are often worked out on tracing paper and then, with oil paint applied to the reverse, they are transferred through pressure onto the canvas. A couple of these working drawings are exhibited alongside finished paintings in the St Clears exhibition. This gives you the clear idea that one painting is made up of a series of paintings; how good it would be to be able to see all these stages as finished pieces, separately. At one point, in the 80s, Selway would leave the edges of the paintings 'unfinished' so that you could see the gradations of layers building up; but later decided that this was rather a contrived affectation, too much of a postmodern 'knowingness'. He felt that such a contrivance distracted the viewer from the painting. Revealing the process of painting was not what he was after. A painting is built, like a house, he says, foundation, walls, scaffolding, roof, and then you take the scaffolding away, simple. "You build from the back, from nothing to something", but its important not to see the evidence of all this background work. He talks of achieving an 'anonymity' by eradicating the signs of hand and arm movement, unlike the predominant twentieth century preoccupation with expressiveness based on revealing the artist's touch, he is more drawn to Vermeer and Goya and, if anyone in the last century, Balthus. The only artist from this century to be mentioned in conversation is Gary Hume, an artist who uses high gloss domestic paint, seems to be a neo pop artist but who is also a very intelligent painter.

In an analysis of the world's current crisis, Roger Scruton[3] cites the dangers of what he calls "the culture of repudiation" that is prevalent in the West. This tendency is exemplified in the way curators of an exhibition showcasing current British art at Tate Britain can write in the catalogue:

Ideas of art as embodying extraordinary creativity, or as somehow transcendent or transcendental, occupying a higher place in human culture, are rapidly losing ground. Instead it is becoming clear that art and artists are not necessarily special[4].

Perhaps it just seems that way because there are too many artists and too few truly transcendent works at the moment. Too much that is only sufficient, that is mere entertainment, and a huge emphasis made on relativism.

Cognitive science tells us that art is part of a material world, our senses respond to art via language and thought and not 'pure' sensation. A painting exists within a particular intellectual framework, without being able to entertain the concept of it in our head, how would we recognise that we were looking at a painting in the first place? Art is not like heat or light, which can be responded to by humans in much the same way as plants. Even so, whilst language and thoughts give us a bearing on the material world, art can and does transport that thinking part of us beyond the confines of ordinary experience. Given the chance it makes us transcend the material. Despite the repudiation of current art world thinking (a world that he has little time for) a painter like John Selway continues to strive for that transcendence.

Tony Curtis, apart from writing and lecturing on art, is also a collector, and the very first painting he bought was a John Selway called 'Twins, Bournemouth':

It is a witty gouache on paper from 1974: the twins are arms-linked, walking towards the shadow of a photographer. It is straight out of Diane Arbus, but her freakish take on life is mediated here by an elegant, but featureless, oversized woman walking out of the left edge of the work; and to the right is a speckled, rather stiff man, with an erect umbrella.

"There is life ... and there is painting," as Picasso said.

David Garner 'Fear of Furniture' (2001) chair upholstered with human hair, jacket, sash-clamp, electric light, 122x95x40cm

David Garner 'End Product (Who's counting?)' (2002)
desk, paper shredder, ballot box, roll of paper
with printed people, lamp, 122x112x122cm

David Garner 'Displaced Family' (2002)
Bales of clothes, table, chairs with candle wax, candle holder, dimensions variable

2.6

THE BARBED RETORT:
DAVID GARNER AT ABERYSTWYTH

Art and Politics, do they go together? Is 'Guernica' the greatest work of protest of the twentieth century, or merely high-class design hanging on the hook of tragedy? Is the Bennetton advertising campaign more successful at political messaging than any artist?

It has been argued that it is due to a failure of imagination on the part of artists that we no longer have an avant-garde; no-one has managed to move on from the breakthrough movements of the beginning of the last century. With postmodernism we don't even try, we just play with styles ransacked from the near and distant past. An avoidance of political statement is more evident than engagement. It would be wrong, however, to entirely dismiss the artist's voice and impact on the political climate of the late twentieth century. There has been a lot of political comment made on particular 'issues', feminism, AIDS, and the signifiers of racial identity. The later cause is evident even in the work of a celebrity artist such as Chris Ofili. Artists from non-Western cultures in particular have never given up on art as a tool for protest and political representation.

It is good to see David Garner given the opportunity to show at Aberystwyth Arts Centre. He perseveres in the quest to present his work and is hugely critical of the apathy and uninterest that he has encountered amongst curators and administrators in Wales. It is particularly important for work such as his to have a regular showing, more so perhaps than a painter's work, which can more easily be shown in group exhibitions. This work needs viewing in the flesh; it needs experiencing *en masse* so that it can

become burnished into the consciousness. Like theatre, which in many ways it resembles, it needs repeated viewing: new works – second, third acts – need to be seen before the memory of the first act dims. Failing a permanent contemporary art space for Wales, it is good that the regional centres of excellence such as Aberystwyth, take on the role of 'national' theatre.

I have a tendency to see the characteristics of an artist's work as reflections of that artist's cultural background, a tendency that has laid me open to accusations of 'essentialism'. Essentialism smacks of the fundamental, the absolute, those things we shy away from in our fractured postmodernity. As long as the essentialism, or nationalism, (another no-no word) is of the right order, when it suits the needs of the right people, then it's OK, in fact there is no need even to refer to it in those rather loaded terms.

If I am talking politics it is because we are discussing the work of a political artist; I am passionate because we are looking at the work of a passionate artist; and I am culturally specific because I don't believe you can take Blackwood and Ebbw Vale out of the making and shaping of this man nor his work. But an artist is of his time as much as of his place. My language is a direct response to this work, and essentialism is something that is strongly suggested here. There is no place for subtle artifice in Garner's work. In a world of prevarication, evasion and doubt, he presents us with certainties, truth to material and the truth of moral outrage. The passionate sermon of the Welsh nonconformist pulpit and the radical socialist is his natural voice. The spiritual aspect of the divine comes a poor second to social and moral judgement in the religious order of these closely related movements of the south Wales valleys. Garner was born in Ebbw Vale in 1958, his father had worked in the coalmines for fifty years and retired only when the industry closed. He had encouraged his son to study, so that he could make a cleaner living away from the pits, but it was to the same area that Garner returned after a period of education in London, to 'get his hands dirty', metaphorically at least, with his studio work. His wife is a local woman and his two daughters attend a Welsh medium school, regaining the linguistic heritage

that Garner, like many, did not himself inherit.

In the centres of our civilisation, real issues of minority culture, of the working class, of displacement and cultural loss, are not being addressed. Rather there has grown a culture that turns everything into commodities, thus silencing, or camouflaging the expression of the ethnically and socially diverse world. Rather than a so called Global Village of smiling multi-cultural tolerance, we are presented with a situation where art that refuses tacit conformity is displayed in the same way that tribal masks used to be displayed; dead and out of context. Ethnicity as commodity, difference as accessory, roots as trimmings. All eccentricities, such as stubborn European minorities, are frowned upon and mocked whilst our cultural elite crow on about multi-ethnic realities. Don't believe them: we are all being moulded into a 'one size fits all' suit, and that suit has 'made in the USA' on the label.

Artists have become preoccupied with establishing a distinctive 'look' for their work at the expense of 'meaning'. In this scenario, which privileges a pursuit of novelty that borders on mannerism, to be aware of art history and convergences is dismissed as 'copying' or revered as 'parody'. The short-term benefit of acquiring a style is in the sense of 'branding' for the marketplace. Political viewpoints are eschewed since they are not good selling-points for a work of art.

There are interesting cases of cultural realignment taking place in a few instances, whereby famous works from the past, recent and distant, are appropriated to make telling politicised statements. Rasheed Araeen for example, parodies Richard Long's line of stones by lining up animal bones in 'A White Line Through Africa' (1988). Thus the white hunter/colonialist rampage is evoked whilst also insinuating a parallel with Long's original self-proclaimed apolitical stance. The suggestion is made that his art is also an act of marking out and claiming territory.

It comes as no surprise that it is predominantly artists from minority cultures who make political statements in their art, by dint of sympathy (often born of experience) towards issues and values overlooked by those artists from within the mainstream. It

is evident, even when these artists are accepted into a mainstream institution like Tate Modern. On a recent visit there, the politicised art of Mona Hatoum (a long-time resident of the West, and once a Senior Fellow at Cardiff College of Art), and Doris Salcedo from Colombia, a country torn by civil war, stood out. Both artists use materials and make objects that induce a physical response before we make an intellectual connection with the issue. Hatoum's use of cheese wire tautly strung, like an egg slicer, across the base of a stainless steel child's cot in 'Incommunicado' (1993) needs little elaboration. Her references are vague but imply interrogation, suffering, torture, concentration camps, the massacre of innocents. Salcedo fills pieces of furniture with concrete, a wardrobe in this case with a chair back protruding from the sealed up mahogany. Again, it is a feeling that one gets. Knowing the artist's origins helps us understand some of the references. The result in both cases is an evocative object rather than documentary evidence.

There is a similar telling use of materials in David Garner's work, but the target of his 'barbed retort' is rather more directly invoked. I first saw Garner's work in 1997; they were wall hanging tarpaulins, made up of a montage of workmen's gloves and coats and then painted over. They smelt of coal dust and damp. They were obviously political; they were about the mining industry, the loss of work, and the loss of meaning. They were direct and they were about something he knew.

The influence of painter Terry Setch on students that passed through Cardiff College of Art from the 1970s up until his recent retirement from teaching is often overlooked. By a process of osmosis, his influence can be seen to touch many artists now working in Wales, and Garner, particularly in his early work, is one of them. Setch is a painter of large expressionistic canvases, often un-stretched tarpaulins in effect. He is also motivated by environmental and social issues. Beach scenes painted near his home in Penarth incorporate oil from tanker spillages, polythene, plastic and cans collected off the beach, whilst he casts a backward look to Sisley's studies of the same beach a century earlier.

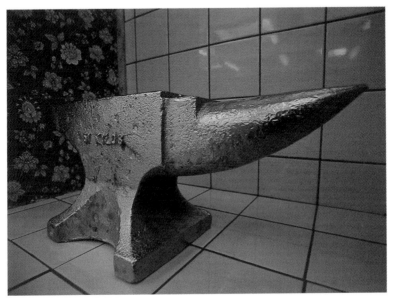

Angharad Pearce Jones 'D.I.Y Mania' (detail) (2000)
nickel plated anvil, installation, dimensions variable

Brendan Stuart Burns 'Edging West' (2001-02) oil on canvas, 220x172cm

Brendan Stuart Burns 'Not the Stillness' (detail) (2001) oil on canvas, 196x508cm

Ivor Davies 'Delw Danbaid' (2002) oil on canvas, 150x150cm

Mary Lloyd Jones 'Mwyn Plwm' (2001) oil on canvas, 150x180cm

Sue Williams 'Do You Know Who Your Friends Are..?' (2003) mixed media, 180x180cm

Sue Williams 'We're No Angels' (2002) mixed media, 170x180cm

Elfyn Lewis 'Mynydd-Bach-y-cocs' (2002) acrylic on board, 43x45.5cm

Neale Howells 'Miss Sharpe in Orea of Wine' (detail) (2000) mixed media, 240x420cm

Karen Ingham 'Postmortem III' (2000) colour print, 24.5x37.5cm

André Stitt 'Resistance' (1999) PFO Odense, Denmark

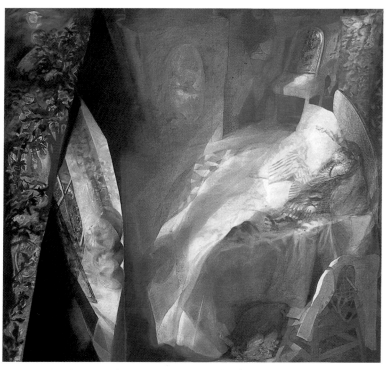

John Selway 'As I rode to sleep', Fern Hill series (2002) oil on canvas, 183x183cm

Geoffrey Olsen 'The Memory of Sporadic Wickedness'
Extramural series (1996-99) acrylic on canvas, 182x243cm

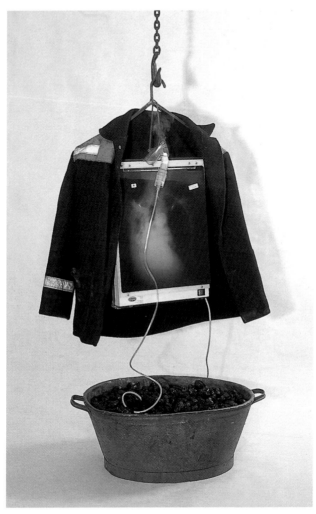

David Garner 'Do Not Go Gentle' (2001) mixed media, dimensions variable

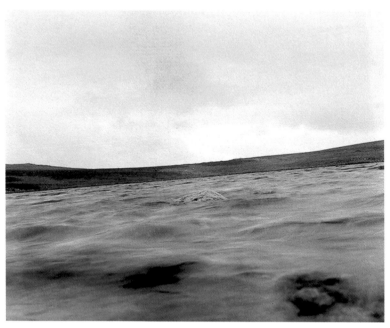

Richard Page from the series 'Landscapes from the Tryweryn Valley' (1999)
'C' type print on aluminium 75x91cm

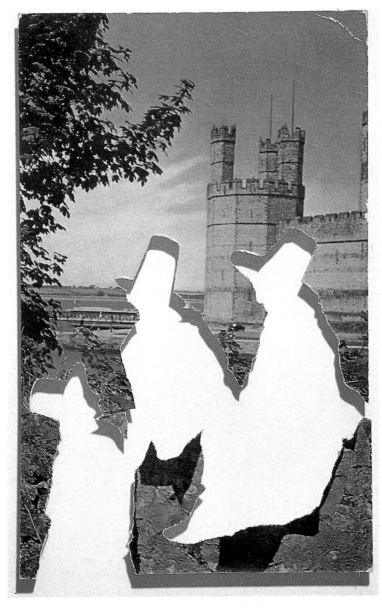

Tim Davies from Postcard Series II (2002)

Garner's earlier work utilises this same system of loosely hung canvas, and a similar depiction of a landscape despoiled, with added objects and materials chocking the surface. He moved on from gloves and coats to the electronic circuitry of the short lived 'new' industries, claiming a territorial stance on this landscape and commenting on the decline of 'traditional' industry with its concomitant sense of community, and the effects its passing has on the political and social landscape. Words are written across the surface, 'Politics eclipsed by economics' sums up the sloganeering of the Thatcher era.

Comparisons with the work of the German artist Anselm Kiefer are unavoidable. Kiefer's vast canvases salvage an idea of Germanic myth that, post-Second World War, had become an embarrassment. Again, the landscape is re-interpreted as a 'field' of meaning, often churned up and excavated, the surface of the work invaded by foreign objects, lead being a favourite addition. He is another painter whose paintings evolve through the gradual encrustation of objects into freestanding three-dimensional assemblages, and then into components of a larger installation. Garner might not have the finance available to Kiefer, but by begging and borrowing and salvaging has made a decent effort to move his wall-hung works in this same direction.

Salvaged school desks led to the large installation dedicated to the memory of the children killed in Aberfan when a slagheap buried the school. A tin bath, a bible, a telephone and a tap make up the smaller, trestle table-mounted homage to Capel Celyn. Stuffed animals, a hare and a sheep have made iconic appearances, with the help of a local taxidermist. Employing local labour such as welders has been a feature of these installations.

In 'Memento', presented at Cardiff's g39 in 2002, Garner concentrated on the emotional residue caused by his father's death, a victim of the mining system, the death certificates notes simply 'Industrial Disease'. His father's breathing mask, an X-ray of his chest, a mining jacket and a pile of coal make up the assemblage. The work bears the title 'Do not go gentle', referring both to the fight to hold onto life and the fight for recognition of the cause of

death. Garner said, "I wanted my father to live more than his eighty-seven years. I wanted him to live longer than the Queen Mother to prove that privilege and wealth are not important." On the top floor of the gallery he recreated a doorway and ash pathway leading to it. Entitled 'History Lesson (what price for coal?)', it is reminiscent of the back gardens and sheds of valleys housing, and a particular era of tin baths and backyards. It is literally a threshold, a point of entrance or departure.

In establishing a genealogy for this work, I might just as legitimately invoke the spirit of the late Paul Davies, who worked with objects in a similar if more anarchic manner. Were Garner to have emerged ten years earlier, there is no doubt that he would have received an invitation to join Davies' Beca Group, which involved the production of political and social commentary.

The new works exhibited at Aberystwyth are essentially individual sculptural pieces, or assemblages, rather than installation proper, but placed as they are in the cavernous new gallery, they assume the overall effect of an installation. One thinks of an airport departure lounge, or some kind of warehouse used for storage. The empty spaces between the works, dramatically activated by the viewer, are as important as the seemingly haphazard placement of objects. Three larger-than-life steel clothes rails or trolleys dominate the space; sharp hooks holding up bales of tightly packed clothes and suitcases, like meat in a slaughterhouse. The analogy is emphasised by having three bales laid onto wooden palettes, a recognisable contemporary sign of non-permanence and portability. The title of this work is 'Production Line'. The bundled clothes reappear in another piece titled 'Displaced Family', set on chairs around a table, on which stands a silver candlestick. The candle wax has formed a question mark on the crumpled tablecloth, one that is mirrored in an assemblage of Lego bricks and small toy soldiers at the opposite end of the table. This was his young son's contribution to the piece.

The titles are not obfuscating or teasing, 'The More You Sing, The More You Risk Your Life' is a bird cage with striped material, such as that used to make prison garb, lining the floor.

Photographs of prisoners of conscience are attached to the bars and a naked light bulb is suspended inside. 'Fear of Furniture' is a chair with a jacket hung over the back, a carpenter's sash clamp pins the jacket tightly to the upright back and an anglepoise lamp is clamped onto the clamp, its light shining at the space just above the jacket where a head should be. Cigarette burns in the seat of the chair are sprouting what looks like human hair.

'End Product', the piece that gives the exhibition its title consists of a roll of paper with a male and female logo, the type you see on toilet doors, repeated on it. As the roll slowly unwinds, it is fed not into, but over a black ballot box and through a paper shredder, so that a continuous stream of paper strips cascade onto the floor. Garner estimated that 15,000 printed figures would be shredded during the course of the exhibition. This kinetic contraption is placed on an ordinary office desk, with an anglepoise lamp that lights up at each revolution of the roll, once every fifteen minutes.

The criticism often made about work like this is that it tends towards the literal, that its lack of ambiguity allows no recourse to thought and imagination. If David Garner's work lacks ambiguity it is because this artist has no time for it, things need to be said. If the work is 'theatrical' then it's all the better to give impact to that which needs to be said, to make sure the viewer does not forget it. Those high priests of chapel and union knew that, as did the Millenarian, Iolo Morganwg and the radical dissenters of the Chartist movement coming from that same strident corner of south east Wales. The work awakens anger; it is not a memorial but a call to arms.

But this is not to say that the work does not operate on a more subtle psychological level as well. The use of everyday materials, doing their usual thing, the sash clamp still clamps, the lamp still lights, but by their dexterous juxtaposition he draws a compelling picture. Inanimate 'things' become surprisingly powerful metaphors. A bundle of clothes becomes, yes, a dispossessed person. Whilst we may say that these metaphors are too obvious, even clichéd, their success comes from that very surprise we get

when we find them so disconcerting in the gallery. We are shocked by our own capacity to feel for these inanimate objects, these clichéd symbols. We are as shocked by our capacity to be surprised by these objects, (that are in reality only ordinary things) as we are by that which is 'told': torture, dislocation, loss. That is just it; it is the ordinariness of these things that echoes what has been called 'the banality of evil'. Yes, a man is as likely to be tortured in a commonplace chair in an ordinary house as he is in a suitably designed contraption in a designated room.

There may be nothing shockingly new about what we are told here, we have read and seen the news, but these works operate on a more tactile level of experience. Like the 'act' of a preacher in a pulpit (or a manic street preacher), they seemingly turn us into first-hand witnesses of history's events. Even though we know we are in a theatre, the action is, for the same reason, live and not mediated. They force us to confront that from which we can shut ourselves away, in the comfort of our armchair in front of the tele-vision.

The work is forthright, not interested in artifice or 'style' and as such they remind me more of art from Africa and Latin America, Poland or Cuba, than of a refined mainstream Europe, even when that art tries to emulate 'the poor mouth'. The passion has not been substituted by empty conceptual statements, nor tarnished by making the 'authentic' experience into a commodity, which invari-ably turns gold into shit. The anger is not dissipated by cynical manipulation. An honest response, an unfashionably righteous anger, turns shit into gold and occasionally even allows us the shadow of a smile. Because this works, though unrelenting, is not without humour, it is leavened with a dry sardonic wit. We smile when we see the detritus – the fallout of the industries, the political decisions that caused the misery – used to make the barbed retort.

2.7
ART AS CATHARSIS: KAREN INGHAM AND ANDRÉ STITT

> The £12,000 takeaway. A man kicks an empty curry carton down this street and, guess what, you're paying for it. Because it's art...

This was the response of the *Daily Mail* on February 6th 2003, to a performance art event by André Stitt, the 'Bedford Project'.

It's a familiar invective from the tabloid press, echoed faithfully by the regional papers, whose mocking stance is a schoolyard tactic aimed at anything slightly unconventional. The purpose is to provoke outrage and ridicule rather than understanding and appreciation, and reinforces assumptions about art that actively discourage people from becoming open to new experiences. 'What's the point of it?' they peevishly demand. If art is anything other than paintings to hang on the wall (and those being romantic landscapes), then what is it for?

Ascribing a role for art might not be wise or desirable, even with the risk of sounding evasive. It is the one thing that can exist without 'purpose' and it can fulfill many different 'roles' for artists and percipients alike. It's a pity that Art for Art's Sake has become a misconstrued and dated concept; now art has to be packaged as 'entertainment' or 'design'. Art used to be seen as a direct challenge to the utilitarianism of the surrounding world. If art now needs more meaning, or new meaning, in a world less driven by the work ethic, then it might lie in the human need for catharsis, defined as "an emotional release in drama or art, the process of freeing repressed emotion by association with the causes, elimination by abreaction. Purgation, cleanse."[1] To confront fear close up and therefore be released from its hold our ancestors employed ritual dancers dressed as wolves and other predators, made more monstrous by the creative imagination of the mask makers. Today

we give our trust to white coated rational science, to the sterile operating theatre and the reassuring doctor's surgery – we trust the 'magic' of medical science to deliver us.

There are critics of contemporary and modern art who believe passionately that art, if not a cause of, certainly colludes with a general de-humanisation of culture. Can art be cathartic in this age, or is it indeed, merely a symptom of a relentless anti-human-istic urge that has allegedly been pursued over the last hundred years? In such a climate, can art ever be seen as redemptive or is it merely a capitulation to the forces of a pitiless aggression against human values and the human form?

This essay discusses the work of two artists who have come to Wales to teach and make art. The two employ different media, but their concerns are more closely aligned than first appearance might suggest. They share a preoccupation with issues of the body and of time. The work of both artists involves photographic recording, but in fundamentally different ways. Recent work by both artists touches on the religious impulse of the human con-dition. Both, in varying ways, deal with their own experiences, and more importantly, with an area of human experience that has been linked with the notion of 'catharsis'.

Karen Ingham's biography tells us that she was "born in England but raised in a peripatetic Texan oil family, moving across the States, and then into Germany and Norway before returning to Britain to go to university". Having graduated in Creative Photography at Trent Polytechnic, she came to Wales to do M.Phil Research and teach at Swansea Institute, in what is now called Lens-based Studies. She has worked in film and video and pro-duced site-specific video installations (as at *Locws International* in Swansea in 2000) and exhibited widely, including at the Montreal Film Festival in 1987 and the Institute of Contemporary Arts in London with a film *Binding Love* in 1997. Her credits include stints as producer/director on the BBC's *The Late Show* and *The Slate*. In 1994 she won a BAFTA award for the observational doc-umentary *Highwinds and Acts of God* shown on BBC Wales. She was the curator of an exhibition of photography *Paradise Park* at

the Glynn Vivian in 2000, accompanied by a book published by Seren.

In the catalogue essay produced for her multi-media work *Death's Witness*[2], she tells of her father's death and of a snapshot of him sent with the note that informed her of his passing. She had not seen him for over twenty years. She goes on to invoke the writer Roland Barthes, who once described the photograph as a 'fugitive testimony'. She finds this

> a particularly apt expression for my father's last image; his is/was a fugitive absence, symbolised as a photographic presence. Perhaps *Death's Witness* is my fugitive testimony, a cathartic exercise in metaphorically dissecting and appraising mine and my family's eventual death, with photographs playing the role of the Shaman, for, like anthropology, photography is a constructed fiction, and the family album is merely a forgery of memory, where death is the scene that is always absent.

Her work in *Death's Witnesses* with its evocation of the Turin Shroud and the Veronicas (originally a handkerchief sized piece of cloth believed to bear the imprinted visage of Christ), also reminds us of a death mask, of *memento mori*, and of Renaissance paintings.

Renaissance artists took advantage of developments both in perspective and anatomy. For the first time human beings could be represented in a lifelike manner rather than as flat approximations. The deposition and Christ on the cross was therefore a 'life-like' representation of death. The attempt to deal with the loss of a human presence leads to an attempt to understand 'presence' itself, as represented by the human body. Gradually the attention of the artist shifts and becomes a fascination with anatomy, the corporeal reality as the 'thing' in itself, removed from a more significant or spiritual 'presence'.

The study of anatomy was presented as a spectacle, hence the term operating theatre. It was not only an attempt to understand the physical mechanics of human life, but of the metaphysical aspects. In other words, the study of the human body is an attempt to deal with the fear of the unknown, to transcend death by gaining

knowledge. In that sense it held the possibility of catharsis.

Karen Ingham explores this theme from an academic and aesthetic direction. In a series of works that follow on from *Death's Witness* she combines elements of contemporary research and references the great painters of the past who recorded these public post mortem dramas.

Visual artists increasingly find stimulus in the sociological and anthropological research models of science, the collated information of the archivist, as much as the visual interpretation of the world. Ingham locates her work astride these two polarities, indeed she shows us how painting in the past has moulded an iconography for science, an inquiry that began in the renaissance and continues with the Genome project of today, the mapping of the human presence.

The furore over Dr von Hagen's exhibited corpses filled with plastic preservatives, and the return of a questionable theatrical aspect in his public demonstrations, raises the spectre of the 'freak show', the Burke and Hare mythology, that was at one point common and which medicine fought hard to leave behind. Ingham's collaboration with university departments and hospitals ensures that she avoids these areas of representation. Her seriousness of purpose and procedure guarantees that her work avoids these voyeuristic overtones, whilst also giving us legitimate reasons to consider concepts, and realities, like the 'Digital Cadaver'.

What does a fine art audience gain from this work that cannot be gleaned from a dip into a medical textbook? There is the same fascination, to see literally, the bones beneath the flesh as Ingham's X-ray type photographs of her own face reveal. Seeing these as art in a gallery reinforces the metaphysical over the physical. It reminds us of our own corporeality and our intellectual efforts to seek beyond that, a seeking that began with god and ends with genetics. These are striking images taken at Morriston Hospital MRI department, which are scanned and printed as photographs. In a video loop made up of MRI 'self-portraits', 'Six Stages of Decay' shown on a monitor, the face metamorphoses into sad and strange monstrous visages in a

process of morphology. The Victorian 'science' of Morphology proposed that all living things were united in a 'chain of being'. As the scans reveal an image that goes deeper below the surface, we are confronted by an animal visage. 'We are also this' seems to be an unvoiced conclusion.

Ingham's work raises philosophical and ethical questions as well as revisiting areas of art history. Is it possible that art can help us cope with the huge moral implications of human cloning and genetic engineering, now within our grasp, where scientists can fine-tune genes in embryos to produce a super race? Perhaps. Artists are finding ways of expressing our deeply rooted anxiety.

Whilst immediate references are made to the X-ray and scientific photography, we are always reminded of 'painting'. Painterly references are brought to mind not only by the subject matter, but also by the process of developing photographs and the creative decisions involved in using digital technology, which opens up the lens-based practice into more possibilities of manipulation. The painter's sensibilities are therefore once more required in the composing and final appearance of the work. A photograph, like a painting, contains layers of meaning and memory. It is, as Ingham says, "a palimpsest, open to erasure and re-invention". A sequence of large scale photographs or 'Shrouds', inkjet printed onto silk, show Ingham and her immediate family. Others show the interior of a hospital or morgue, clinical, clean. 'Postmortem', a series of colour prints 245x375mm, show scenes from autopsy rooms, with tools arrayed on stainless steel tables, refrigeration doors, discarded latex gloves in a sink. What can we deduce from these images? What are we to think?

> In a sense perhaps all images are shrouds, masking, veiling, cancelling truths under layers of obfuscation, layers that must first be stilled, before dissection and analysis, and finally laid to rest in our tomb of memory.[3]

In capturing and stilling a moment, the photograph, like the morgue, becomes the 'uncanny tomb of memory'. Sterile and clean.

Karen Ingham 'Death Shroud' (1999) inkjet printed silk

'Death's Witness' (2001) MRI scan, digital print

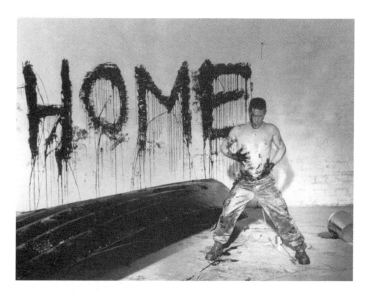

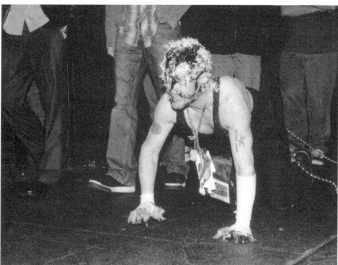

André Stitt 'Home' (1999) Forum Box Gallery, Helsinki
'The Soft Parade' (2002) Downtown Los Angeles

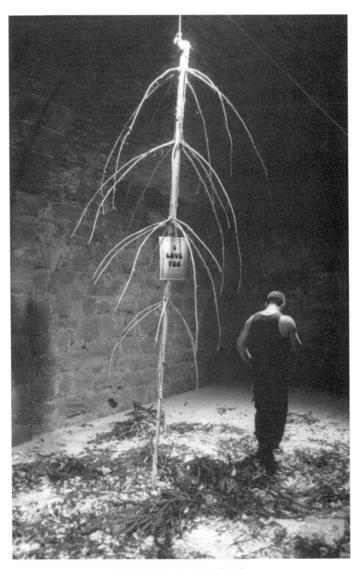

'The Envoy' Stadtgalerie, Bern (1998)

Clean is not a word one could use for André Stitt's performances, which are 'painterly' at the most primeval level. He calls them variously "a journey towards redemption" and "a language drawn from deep memory". A memory from his Belfast childhood is of women with heads shaved, tied to a lamp-post, tarred and feathered. One thinks of this when viewing a piece performed in Helsinki in 1999 called 'Where the Grass is Greener', molasses are used to coat a rowing boat which is then launched into the water – cast away, as if to purge a painful memory. In 'Conviction' performed on a Belfast street in May 2000, he crawls along the pavement amongst the shoppers, his head tarred and feathered, before entering a pub and nailing several pictures to a pillar.

With a large Cuban cigar in his mouth, he daubs a painted mask (like those hoods with eye holes favoured by terrorists and militia alike) onto a canvas hung on a wall of a derelict room. This piece, called 'Colony' is performed in Limerick, 14th May 1999. The audience stands around as he paces agitatedly around, screaming something that sounds like 'Billy'. He throws handfuls of feathers at the mask. He straps a wooden cross to his back, lights a fire, turns on a tape of 'All the Young Dudes'. Ripping the canvas down uncovers an open doorway through which he walks out into the street. Feathers are often used, sometimes thrown, sometimes attached to armatures and strapped unconvincingly to one arm, which is then trussed behind his back, like a broken wing. Icarus brought to ground, he hops around on one leg, crashed and burnt.

If the photograph plays the role of Shaman in Ingham's work, Stitt actually becomes a Shaman in his 'akshuns'. Visceral, bloodied, tarred and feathered, possessed by a raging energy, his performances thrill, horrify and transport his audience. There is no question of these being the performance of an actor playing a role. That's where it differs from theatre; they are frighteningly real. There is no polite bow to be expected at the end. Maybe this is a cliché, this talk of shamanism; does he see himself in that way? "Am I a shaman, am I fuck," he says, but relents a little and recognizes that an audience needs perhaps to believe that he is.

People need to understand by 'naming'. And yes, the perfor-
mances do 'release' him, though not in any prescribed way. It has
taken years to lose the egotism that always threatens to ruin a per-
formance, the adolescent showing-off. Years to build the control
needed to avoid doing something merely 'entertaining' or
'showy'. A performance might be motionless; when and why
would he decide to move? Would he do it in order to entertain a
bored audience? Would he allow the artwork itself to dictate his
next move? Like a painter wrestling a work from canvas and
paint, does that painter add a skyline to make the work readable
when he or she knows in their heart that is not what the integrity
of the work demands?

"Art is not a mirror it's a fucking hammer" is scrawled onto a
wall in a space that is neither gallery nor stage. A semi-naked, tat-
tooed, compactly muscled performer does things in the space. It's
a line that echoes through this artist's work, art should not reflect
back to us a false surface that merely confirms existence; it should
be a hammer that shatters our placid self-acceptance. Confronted
by these artists' work we are forced to address the question of the
role of art here + now, or what, perhaps, its role should be. An
influential book by Suzi Gablick, *The Re-enchantment of Art*[4] sug-
gests that art should cease to be seen as a mere entertainment, that
far from being a healing or transformative process for the artist
alone, its role is to heal culture as a whole.

Some of my previous essays have proposed that the artist has a
role as Remembrancer, which to a certain extent both these
artists are. But more than this they bring us face to face with our
own (limited) existence, this Small Time Life, and what we make
of that short allotted time that we have in a social sense. Charles
Bukowski, an inveterate chronicler of his own 'small time life', is
quoted by Stitt, "What matters most is how well you walk
through the fire".

André Stitt's particular 'walk through the fire' began when he
was born in Belfast in 1958. It would be too easy to connect that
fact to his chosen medium of work as a live artist. To date, he has
clocked over 400 performances since 1976. These 'akshuns', as

he calls them, echoing the particular accent of Belfast, are a result of his formative experience. That his course of action is culturally determined would be difficult to refute. On a simple level, contact with performance artists abroad became an escape and a network of information whilst he was in Belfast: "a place nobody wanted to come to". An escape from real, casual violence into an aspect of control over violence within his own work is inevitably linked to his background. This is acknowledged in the artist's numerous statements about his work, not all artists are as trenchantly honest or self-aware. His work however takes him beyond the confines of narrow specificity, to deal with oppression, freedom, subversion, experiences of alienation, appropriation of cultures, transgressive and ritual 'akshuns' that feed from the local, be it in Poland or Tokyo or Cardiff.

Without his formative experience however, it is doubtful whether he could fully place himself into these performances in the way he does. The akshuns have evolved to become an everyman's raging against the forces that control us that we cannot see, let alone stand up to. Most of us, everyman each, do little about it and therefore we need a suitably 'gifted' or 'chosen' individual to do it for us. This is the place of the shaman, the trickster in today's disconnected age: "The trickster's role is to add disorder to order and so make whole within the fixed bounds of what is permitted." Each culture produces its shaman, singers, painters, poets, but what many of these people create is too easily bought up and sterilized by consumerist life-styles. Performance is, historically within modernism, an attempt to create art that cannot be commodified, that does not sit easily within bourgeois notions of taste or acquisition. Attempts to make Performance into an event that can be rehearsed and repeated (and therefore provide steady income) have, according to Stitt, compromised its role as art and made it into theatre. The Arts Council of Great Britain attempted this with its 'Live Art' project in the 1980s.

Stitt declares a childhood fascination with the 'trickster' mythology, in particular that of North American native tradition. His work from 1979 became part of "a sort of contemporary

trickster cycle ... the performances became ritualized, a journey to the heart of contemporary addictions.". In *Performance Magazine UK* he is described as "perhaps our shaman who is prepared to explore what most of us would not care to be, let alone even try and express".

The trickster – and the shaman – bears a burdensome load. According to Jung his profession sometimes puts him "in peril of his life ... at all events the 'making of a medicine man' involves, in many parts of the world, so much agony of body and soul that permanent psychic injuries may result ... his 'approximation to the saviour' is an obvious consequence of this, in confirmation of the mythological truth that the wounded wounder is the agent of healing, and that the sufferer takes away suffering."[6]

The shaman, in his or her endeavours, risks psychotic break-down in the course of their training, a condition not uncommon amongst performance artists either. For Stitt the burden of such responsibility, coupled with responsibilities in his private life resulted in a crash, an escape into real addiction, a long falling from which he awoke only at the point of death. Death plays its part here in Stitt's work as in Ingham's; in the statements made by Stitt, the experience is invested with mythic potential. Death and rebirth really took place for him, and are revisited in perfor-mance. He became a witness of his own death at the end of a drink- and drug-fuelled slow suicide – and a redemptive rebirth. Since then his life and work have attained a new focus and disci-pline, even achieving at times, notably with the 'I Love You' pieces, an almost Christ-like serenity. These performances demand weeks of meditation and preparation.

Photography plays a crucial role in the way time-based perfor-mances come to be 'constructed' for posterity. Yves Klein, the French artist, famously staged a striking performance gesture in 'The Painter of Space Hurls Himself into the Void' (1960) by using a montage of photographic images. These were structured so that a relatively safe jump into a tarpaulin safety net was transformed to show the artist taking an awesome leap into nothingness. These images were then printed in a spoof newspaper, which insinuated

them into a mass circulation and dissemination. It remains widely reproduced much like the image of Josef Beuys in the company of a coyote from a performance piece (1974), or of a naked Carolee Schneeman reading from a scroll extracted from her vagina in stills of 'Interior Scroll' (1975).

Images like these, mostly reproduced in black and white, serve to condense performance art into an illustration to accompany a textual analysis and, like famous cinematic stills, they manage to create an aura around themselves. Stitt describes these photographic objects as seamless extensions to the performance. These aspects of dissemination, the photographs, posters, flyers and cards advertising the event, are elements of the whole work. Stitt is a painter and performance is only one outlet for his creativity, albeit one that focuses attention and one that is supremely suitable for myth-making. People often believe they have been present at a performance, when in fact all they have seen are photographs and secondhand impressions of those who were there.

Videotapes of performances can be acquired – but the experience of watching them is unfulfilling, incomplete. Perhaps it would be better not to keep a record, not to have permanent evidence beyond that which remains in the memory of those present. And yet I am glad to have been able to view them even once removed from the action: it is powerful stuff.

We speak of 'performance art' yet all art has elements of performance. It's a performance done in the privacy of the studio usually. The planned painting studio in Stitt's terraced house in Splott has become an 'installaction artspace' where artists from around the world appear to a small audience once monthly. Traces of each performance are stored in the fabric of the building, as memory or artifact; logically, the venue is called Trace. Objects that are the results of these performances, as in Stitt's own presentations, are invested with a 'charge', the energy that the performance expended, the ritual action seems to leave its residue. All artists make different performances, a fact which is reflected in the results of the performance, the finished artworks. Some may bias action over thought, some reflection over action, some are

untidy, messy, some fastidious, ordered. Performance has the added component of allowing the viewer into the private space of creativity, as if a painter let people view that process of making a painting. Added to that, is the dynamic of the 'event', the way an audience response affects each performance causing it to move in different directions. The sense of 'meeting' as an audience of a particular event is strong, as is the generosity evident.

When I embarked on this essay, I thought it would take me as far away from painting as it was possible to get in visual art. In fact it hasn't. Performance is in its own way, a painterly act. A performance is given a framework, into which energy is poured. Accidents, intuitive improvisation, decisions follow similar patterns. A painted mark is invested with similar 'ritual energy'. The photograph also becomes an object invested with 'energy'. We know the common myth about the camera stealing the soul. Ingham's work brings us into close contact with that. Life presented as dead matter – which in the end is what every photograph does, although, paradoxically the photograph itself is 'alive' – a constant reminder of a moment that is past or a person that no longer exists.

André Stitt and Karen Ingham are artists that lead us through a doorway into an esoteric, cult-like knowledge. Performance art has its dedicated magazines and websites. The world introduced in Ingham's work is also set apart, the inner circle of medicine and science. In the work of these two artists, there is the possibility of uniting two oppositional methodologies in the continuing human drive to deal with life and death. One appears cool and detached, like a research scientist, or more fittingly, a pathologist, carefully accumulating evidence. The other letting go, it would seem, taking a walk on the wild side. Both methods draw from established traditions which are adapted to the use of artists to pass on an experience to an audience that is liberating, challenging and sometimes scary. Both artists confront the taboo of our contemporary society, a society so materialistic that it cannot accept death as a natural end. We have become obsessed with a popular iconography of romantic death; from James Dean to

Princess Diana. Celebrity guarantees deathlessness, Elvis lives! We don't just want fame we want immortality, and all that that guarantees is a dread of termination.

There is a strand of thought that sees contemporary art as an agent of dehumanisation, one that began with the deliberate breaking down of conventional representation, the abstraction of nature and fragmentation of the human form. These developments, from Expressionism to Cubism to Surrealism, are conveniently attributed to (and even blamed for) the actual fragmenting of human bodies in the trenches of the First World War, and the erosion of humanistic values that followed and were epitomized by the Nazi concentration camps and the experiments with eugenics that culminated in the Second World War.

By these accounts, art's abnegation of the cause of 'humanism' is evident in its lack of 'pity'. Singled out in a litany of accusations are the 'theatre of cruelty' methods of performance art, and what is seen as the pitiless, dehumanizing gaze of the artist/scientist. This view contests that the art of the twentieth century has colluded in the stripping away of humanity and the erosion of pity. Chief amongst the proponents of this view, holding art to be a signpost on the road to perdition, is the French writer Paul Virilio, whose many essays on the subject[7] suggest that he believes art can and should somehow be 'out of time', above the common herd, as he imagines himself to be. I think he misses the point. Artists respond to the human condition and cannot ignore its tendencies, nor offer a fake utopia. By questioning and emphasizing, 'drawing' out these tendencies within society, the honest artist attempts, not always successfully, to hint at ways of 'walking well through the fire'. The beauty is found in the honesty of the attempt, and not in any pretence of beauty. The performances of Stitt are full of 'pity' and truth, and perhaps there's enough beauty in that, all we can ever hope for – and immortality lies, as Ingham's work shows us, in the traces we leave behind, in our DNA.

2.8
"WHAT'S HE BUILDING IN THERE?"
ART OUTSIDE THE GALLERY

Over the past twenty years and more, Cywaith Cymru . Artworks Wales, known as The Welsh Sculpture Trust until 1991, has done a tremendous amount of work in the field of public art in Wales, both with commissions and residencies. When I joined Cywaith, as Project Manager, I felt I needed to write down some initial thoughts on that intangible concept 'public art'. What did it mean, and what might it mean in the expanding field of contemporary Art.

'Public art', as art terms go, is not the most inspiring – what it does inspire is a ream of preconceived notions, of monumental sculpture in 'public squares' or outside 'public buildings'. Of worthy (or unworthy), men and women (men more often) commemorated and great historic events memorialised, or more recently, abstract sculpture that no one understands but just gets used to. Anthony Gormley's 'Angel of the North' is an icon of recent large-scale public art, but a far more interesting and involving aspect of public art operates in another of Gormley's creation, the series of 'Field' installations. This unique project is produced in collaboration with the local populace in places as diverse as Mexico and Lancashire. As 'Field for the British Isles' it was shown at Oriel Mostyn, Llandudno in 1994 and has been created for a fifth time recently in China. This repeated exercise involves the formation of thousands of little figures with no features save eyes, made out of local clay by volunteers. These are fired and then exhibited *en masse* (192,000 in China) in galleries and, in the case of China, in an underground car park. Gormley made this comment about his intentions, "I am trying to put art back where it belongs in a world it should never have left". In the second part of this essay I look at some public art projects in

Wales that have similar aims, but first I will address some of the questions that public art raises.

1

A song on Tom Waits' 1999 album *Mule Variations* tells of a neighbour who is making a lot of noise, hammering, sawing, and banging. The lights go on at odd times, stories begin to circulate about him, rumours abound. We imagine all sorts of possibilities. The singer asks repeatedly "What's he building in there ... what's he building in there?"

It seems that the same anxious, irritable puzzlement remains the response to public art. Art in the public realm is confrontational, whereas art in the gallery, well, you can take it or leave it. It is always easier to be dismissive of anything that is non-representational, easier to avoid having to make an effort to understand and take on some new information, to make decisions based on that. The attention of the press is frequently hostile and damaging to any programme of work. What are they building in there? We don't like it. No one asked us. Waste of money. This defensive attitude prevents us from imagining new possibilities. Perhaps that should be its function, disturbing our habitual programme. Art, according to this theory, should disrupt our daily ritual, provoke people to ask questions; does Art have to sit there in the environment like an ornament on a dresser? And if it does, is it Art or something else? Does being an ornament preclude it from being Art? Who tells us what Art is? Public commissions raise issues of ownership, the man next door surely has a right to build whatever he likes in his own shed, and yet it encroaches on our space somehow, disturbs our peace of mind ... it somehow threatens our land rights in relation to 'next door'. So what the hell *is* he building in there?

What then of the communal public spaces of a city? Who decides what is to be erected in those places? Does sculptural intervention in these spaces, 'open up' or 'close down' the access to the public? Can serious art ever develop through consensus? In a commercial gallery sense, 'consensual' art would be the art

that appeals and sells to the wider audience; it looks good, colourful, cheerful i.e. decorative, whereas 'serious' art, whilst having more impact perhaps, is not art that people necessarily find easy to live with at home. Those who are willing to do so are appreciative of the cultural context, the concepts, ideas and expression of the work, as much as its immediate visual impact. Even more fundamental is the question of art's public function in society, unless it touches people's lives in a meaningful way, what exactly is its point? The question is not only 'what are they building in there?' But 'what is it for?'

The city itself is arguably already a work of art, an installation, a performance space, and a space full of sculptural architecture, good and bad. To add to this with so-called 'public art' could be seen as an irrelevance, a passive collaboration with the grand gallery of the city, its ideological theatre and architectural-social system.[1] The argument for 'art' in such an environment would suggest that it has relevance only when it does what art does best, that is to question and challenge the certainties and orthodoxies of the environment it finds itself in. That is, it is better art when it upsets people.

Public art as it is today is, of course, only a recent manifestation of a timeless human need to embellish our habitat and surroundings. Reasons for this passion for adornment and monument-building change over time: territorial, defensive and religious. A great deal of public art today seems to be designed to operate much like graphic design does, it enlivens a magazine layout rather than functioning on that deeper level that works of art lay claim to. Works of public art can also be seen increasingly as product logos, advertising the new development areas of a city: place-marketing in other words, and public art of the sculptural, permanent kind usually thrives in such areas. Public art is also meant to function as an *aide memoire*, where a dockland or a coalmining site needs a handy heritage marker to tell us, 'yes, once there was all this here, now it's all gone'. A simple poem might do the same, to ward off the extinguishing of our cultural memory; indeed in Wales poems have done that exceedingly well until people stopped reading.

There is a growing need for art to mark or stand in for 'memory' – where cultural and social processes have vanished and need commemorating. Marc Guillaume writes,

> the obsession with patrimony, the conservation of a few scattered centres, some monuments and museographic remains, are just such attempts [to compensate for the loss of social representation in urban architecture]. Nonetheless, they are all in vain. These efforts do not make a memory; in fact they have nothing to do with the subtle art of memory. What remains are merely the stereotypical signs of the city, a global signal system consumed by tourists.[2]

In the still undeveloped hinterland sprawl of Cardiff Bay, how do you give people directions to get from A to B? You use a trail of marker signs. From Eilis O'Connell's 'Secret Station', a pair of conical towers, and onwards to what has become nicknamed the magic roundabout, (a whole pile up of road signs called 'Landmark' by Pierre Vivant), past John Gingell's 'Blue Flash and Mesh Chips', a zigzag cartoon flash atop a big red box, and so on, creating things that become beacons of recognition in a largely alien environment. This has become a major function of 'public art'.

Often, the term 'site-specific' is applied to public art, which is in truth nothing of the kind. Site-specific implies that a particular work of art could only work in the particular place where it is sited, and nowhere else. That it has some physical or socio-cultural attachment and relevance to that place which would be compromised if it were placed elsewhere. Of course, that might mean as little as slight adjustments made from site to site, or a work that is either physically or psychologically made in a way inseparable from its precise location, that it introduces the viewer to a 'sense of place'. The latter might tie the work to an historic or mythic event that took place at that location, or, as in the case of the former, it is designed to respond to or reflect some natural or architectural motif in the landscape where it is placed. Of course, you could have a postmodern piece, and then all you need is irony. A great deal of second-rate Modernist work becomes quickly dated. Would you still have that 70s wallpaper in your living room?

When has the artexed plasterwork just got to go? Maybe redecorating these spaces needs to happen every now and then.

Placing art in the real world, outside the gallery, is extremely difficult. The art, and the response to it, is diminished. Imagine Leonardo's Sistine ceiling painted on the external wall of a modern concrete building. Would it really have the impact it has where it is? The Mexican muralists addressed this problem with awesome scale, monumentality and 'message'; Siqueiros, in particular, introduced extreme perspective shifts to make an impact.

Sculpture meant for a gallery, to use a clichéd expression 'art for art's sake' pieces, rarely work outside, unless you have a cloistered courtyard to put it in, a roofless square box, a gallery in other words. Otherwise a public artwork has to dominate by sheer scale, like Richard Serra's huge 'Cor-Ten' steel slabs. Whilst Anthony Gormley's 'Angel of the North' is no way near his best work, it's not bad as corporate logos go. It draws attention in the way that exhilarating architecture draws attention.

There is another way to draw attention, and by doing so make the public mind begin to work on a level more than perhaps mild surprise or indignation: the best public art should encourage the return to that primal response ... what's he/she building in there? Or more to the point 'what the hell are they doing?' since public art need no longer mean permanent pieces of sculpture, work could be ephemeral leaving nothing more permanent than a memory. But it will be a memory different to all other memories, something out of the ordinary, like a walk in the woods for a city dweller. In some ways then, these 'environmental installations' share more common ground with performance art than the earlier models for public art: the Mexican muralists, or the U.S.-inspired sculpture in public spaces. Art has become an expanded field, with a growing proportion of contemporary practitioners no longer coming from traditional art school backgrounds, a tendency also reflected in the realm of public art.

Claire Barber 'Treading Lightly' (2001) felt booties hanging up
Bardsey Island Residency. Cywaith Cymru . Artworks Wales

Rawley Clay, intervention, Beddgelert Residency (2002)
Cywaith Cymru . Artworks Wales

Jennie Savage, installation, Chapter Bar for 'Fresh' exhibition (2002)

2

Treading softly in felt slippers made from the wool of the last in the line of Bardsey island sheep, the end of a long dynasty. Stepping lightly so as not to disturb the ghosts of the island's 20,000 interred Celtic saints. The artist Claire Barber hangs out to dry a line of felt shoes, made to fit the island's few remaining children. She hangs a swing for children in the mouth of a cave.

In 1999, Cywaith Cymru . Artwork Wales initiated a programme planned as a five-year project in partnership with the Bardsey Island Trust and Oriel Mostyn, which introduced visual artists onto Ynys Enlli (Bardsey Island) off the Lleyn Peninsula in north-west Wales. So far, the artists Trudi Entwistle, Ben Stammers, Claire Barber and Susan Adams have worked there. Enlli is a sacred site and one redolent with legend in the Welsh pantheon of important landscapes. The artist and writer Brenda Chamberlain lived and worked on the island from 1959 to 1961 and published *Tide-race*[2], a memoir of her times there. Claire Barber was the third of Cywaith Cymru's resident artists on the island. One of the first things she noticed on arriving in the summer of 2001 was that there were no sheep left on the island as a result of foot and mouth disease. An unbroken genetic strain of sheep that had lived on Bardsey, going back perhaps several hundred years, had ended. Introducing new sheep would not restore things; new sheep would not have the same genetic links passed on from mother to daughter, through which they know instinctively every pathway, every danger, and every place of shelter. Symbolically, this was the end of an era. Barber collected the strands and tufts of wool that had caught on the fences and brambles.

Remembering the story about all the saints buried on the island, she felt that the children who still dwelt there should have slippers made to 'step lightly', so as not to disturb the slumber of these hallowed ancestors. The wool became felt which became shoes for the children. One large shoe, large enough for an adult to lie in, was made to provide a warm location for gazing at the shooting stars in the island's clear night sky. Swings were made in

the empty cowshed, symbolic of keeping feet clear of the ground, and became popular with the children. Claire Barber talks of the way she became an integral part of that small community, the cowshed where she lived became a drop-in point. Her shoes were made to fit each child's feet. People collected and brought her things, and, as they helped to compress the fleece into felt over a two-week period of stamping, a kind of dance evolved. One can image the timelessness of such a scene, an occurrence at odds with the sedentary, passive nature of much of today's life. One can also imagine how the children will always remember that time when felt shoes were made for them, they will have the shoes as keepsakes. In many ways, something more precious and lasting has occurred than the placing of a permanent bronze or stone monument on the island.

A dishevelled young man in the hills above Beddgelert, living in a silver birch cabin, bare except for a sleeping bag and a statue of the Buddha. Washing himself and his clothes in a mountain stream. Hammering and banging, what's he building in there?

Rawley Clay spent three months in Beddgelert in 2002, working alongside and with the local community, on another Cywaith Cymru residency, funded by the National Trust. It might have appeared strange to the inhabitants of this small town in the heart of Snowdonia to have this stranger living in a wooden hut in the woods, offering to work with them on 'art' projects. He integrated with the villagers, drinking in the pub with the drinkers, smoking with the smokers, sharing tea with the elderly ladies. He found things out, he introduced possibilities, he held workshops. As an itinerant, he managed to reconcile opposing factions. He became the 'village artist', a functional element in the village's social makeup. He discovered links to the previous inhabitant of his forest dwelling, a man who had come for two weeks and stayed for eight years, built a waterfall, become a figure in the social fabric of the area. Rawley's work became a celebration of that man and his existence. One project centred around the cabin itself, what Rawley came to see as the real 'residency', where he channelled the waterfall through the window, over his

bed and out again using corrugated iron sheets left to rust around the place. He painted the cabin, invited locals up for a party; they all came, walking up the forest path illuminated by candles lit by the village children.

In the bar of Chapter Arts Centre, Cardiff, a corner has mutated into a traditional pub with all its paraphernalia.

This is an exhibit in the *Fresh* exhibition organised by Chapter Arts Centre and g39 in February 2002. It could be argued that this installation by Jennifer Savage is not 'public art' in the strict sense, since it is exhibited within the space of an art centre. However, by being positioned in the bar, an area more akin to a school canteen in effect, it is encroaching on public space. That is to say, it makes its presence felt to people who have not chosen to enter into the gallery with the express purpose of looking at and attempting to enjoy art. The artist herself had never felt comfortable in the old-school-done-up-as-arts-centre bar, and so re-invented it as a traditional Cardiff Brains pub. The irony might lie in the fact that very few such pubs remain unmolested, but there are a couple just round the corner: The Butchers and the Canton Hotel, hostelries which I always preferred, given the choice. The clientele in Chapter is a knowing one, I wonder what the effect would be of a reverse proposal, what if the Butchers Arms was turned overnight into an arts centre bar, I guess that then it really would be 'public art'.

Led by the Beca artist Paul Davies, a bunch of people gathered in the mud at the swamped field of Fishguard's famous rained-out Eisteddfod of 1986, building something. We can barely make it out, but it looks like a massive map of Wales. Peter Finnemore on the Eisteddfod field in Llanelli (2000), places seeds on the floor of a beat-up garden shed to form an outline map of Wales. What's he building in there?

On the *maes* of the National Eisteddfod of Wales in Llanelli, close to Peter Finnemore's home in Pontiets, a common garden shed was erected; sometimes it stood within a tented structure, sometimes outside, next to it. In this, another intervention on the Eisteddfod field by Cywaith Cymru, Peter recreated something

of the fantastical air of his photographic *mise-en-scène*. A plea for a disused shed was broadcast on Radio Cymru, and one was duly delivered, garden shrubs were placed around it, a trademark large sunflower stood tall in front. During the week of the festivities, an ongoing programme of events took place within and around the shed, mirroring the more august events within the main pavilion nearby. The loose theme seemed to be the lyrics of the song 'In the year 2525...' Artist Tim Davies did a stint on drums one day, jazzman Wyn Lodwick performed another day. The artist Elfyn Lewis painted and assisted with the burning (inspired by, and reminding us of the political activism of Saunders Lewis, D.J. Williams and Lewis Valentine in the 1930s). The poet Elinor Wyn Reynolds recited a selection of her poems on Tuesday. A male voice choir performed a rendition of the Zegar and Evans song, in Welsh, twice by popular demand. People gathered to chat as is their wont on the Eisteddfod field, but here they seemed to focus their discussion on the out of the ordinary, on art ... they thought of new possibilities.

It's tempting to see this recourse to the non-permanent and ephemeral as a reflection of the times we live in. The task of the artist in the past was not only to aggrandise the powerful, but also to create long lasting monuments to timeless values. In today's culturally unstable and sceptical age, it often seems that immediacy – a heightened present – is everything. Heroic sculpture seems anachronistic outside of totalitarian states, as we focus more on the 'feet of clay'.

There is another aesthetic abroad, one that is brought to mind looking at the work of Mike Nelson, Turner Prize nominee in 2001, or the work of Polish artist Miroslaw Balka, or closer to home where Sally Matthews makes animals, sheep, horses, wolves, out of the fabric of the woodlands where the sculptures stand. Gradually they erode and rot, fall back into the vegetation. Tim Pugh's interventions in the landscape are even more fleeting. Wood is favoured above bronze and marble, exemplified in the work of David Nash and Richard Harris. Peter Finnemore's created 'garden' or Rawley Clay's equally alternative world

engage with the ramshackle, the cobbled together, the comfort of the tatty and old, of recycled leftovers. These conscious acts of creativity look unfinished, frozen in mid-process. In a world which is being overrun by high technology, which glorifies in a veneer of 'finish', of pseudo-sophisticated façade, where reality is partitioned off, where there is an increasing guilt-laden pressure to get things done, perhaps the cutting edge of art lies in reacquainting us with the beauty of the 'unfinished'. The garden shed, the forest cabin, the pub that time forgot, the rope swing in a cave on a legendary island.

People, whether the public or those on the local authority boards that decide on commissioning, are far more receptive to new ideas once they have met the artist, once the stranger hammering away 'next door' has come out of the shadows and shared thoughts on ideas, explained what the banging is about.

> I heard he was up on the
> roof last night
> signalling with a flashlight
> and what's that tune he's
> always whistling...
> What's he building in there?
> What's he building in there?
> We have a right to know...

2.9
WHERE TO SHOW? WHAT TO SHOW? WHO TO SHOW?
(CARDIFF AND VENICE)

Cardiff has been a city since 1905, a capital city since 1955. It is the most populated conurbation in Wales and can justifiably claim to have one of Britain's oldest multi-cultural areas in its docklands. Visitors to south Wales enter on the M4 from London or arrive at an international airport (of sorts). The relationship between the capital and the rest of Wales is often strained. Viewed with suspicion and envy it has few traditional claims to allegiance from the surrounding 'native' encampments. Once a Roman fort, then a Norman stronghold, an Anglicised (with elements of Irish, Chinese, Yemeni, Greek, Italian) industrial port, finally home of a devolved parliament (of sorts). It is culturally very different to the north and west of Wales as well as geographically distant, whilst its political position is more idiosyncratic than perhaps it should be as the centre of 'all Wales' politics. The assumptions it operates on are often a different set to those elsewhere in Wales, and its awareness of this fact is sometimes dim. Visual arts have a role to play in a changing awareness of Cardiff as the capital. It is here that national institutions need to root themselves first. Here that the outside world needs to find the cultural identity it seeks when it chooses to focus on Wales.

There are indications that we may finally be on the verge of establishing a National Gallery for Wales in Cardiff. The likelihood is that it will be an extension (with its own entrance) to the National Museum and Gallery of Wales in Cathays Park and that it will house a permanent collection of art right up to the present. No doubt there will be controversy over the way that exhibits are organised and by what criteria they are judged. This is only one part of an equation that should also include an exhibiting gallery for contemporary art. In line with provision in all capital cities and

many provincial metropolitan centres, the new gallery should be a large scale exhibiting space, which could hold major exhibitions of international art alongside exhibitions of artists from Wales.

What is needed is a stage for Welsh art within a theatre that is visible from Beijing to Sao Paulo. Cardiff 2008, an organisation set up to vie for the prestigious title European Capital of Culture, proposes a significant, if temporary, addition to the scene in the form of The Depot. The plan is to adapt the former tram depot in Grangetown as a contemporary art pavilion. It is to be a creative space, initiating artist-led shows and allowing experimentation. The Depot is an unknown quantity at this stage, a hostage to the fortune of Cardiff's unsuccessful bid perhaps, but should it happen, it promises to be a launch pad that Welsh and Wales-based artists need to achieve a profile in the wider world, and to enrich practice here by bringing in, one hopes, relevant international shows. I wonder whether the unpromising location will be helpful in attracting an audience other than artists and dedicated friends. It sounds exciting as a concept. Concepts generally do. If it, or something similar doesn't happen, if it proves to be empty rhetoric on the part of Cardiff, where does that leave us, how difficult will it be to raise enthusiasm yet again?

The Centre for Visual Arts in Cardiff closed a mere year after its celebratory launching. Several factors conspired to cause this catastrophe, a failure of concept, of the business plan and architecture, but mainly because it was perceived to be an imposition rather than a grass roots initiative. On the one hand, few were willing to pay to see the contemporary art that was shown there, on the other, the exhibiting spaces were unsuitable for any major undertakings. Too small and too many windows. The exhibition programme was by no means without merit, despite a tendency to relegate Welsh art to the basement. Its closure makes the lack of facilities more noticeable than it ever was before. We are also left with egg on our faces, and a 'previous history' which will be hard to shake when trying to convince investors of the public need for a large contemporary art space in Cardiff to complement a growing number of smaller, 'grass roots' spaces like

Tactile Bosch, Bay Art, Trace, Oriel Canfas, Capsule, and g39.

Cardiff needs to establish itself on an international stage, the bid to be European Capital of Culture in 2008 was only one way forward, but we must avoid the tendency to rush into unmeditated tactics, playing semantic games with terms like 'internationalism' and 'new confidence' which are antipathetic to cultural relevance. We could easily achieve a similar goal by engaging in a more interesting dialogue that does entertain notions of cultural difference, identity and specificity.

Just such an agenda seems to underpin the newly announced Artes Mundi prize. This Wales International Art Prize is to be given biannually and offers a healthy £40,000 to the winner, with an additional £30,000 for purchases. Shortlisted artists will have their work shown in Wales, and will also hopefully visit and participate in residencies and joint ventures with Wales' artists. The unique point of this prize is that the artists will not be previously known, nor established in Britain, they will be artists from the 'peripheries', places like Uraguay, Uganda or Iceland, or artists picked from the emergent biennales of Johannesburg, Sao Paulo, Havana and Singapore. It's an expensive and courageous step for Wales to take, and I pray for commitment to its continuity. But this is as yet another unknown quantity, its effects hypothetical.

Artes Mundi is, of course, a prize offered to 'contemporary' artists. When the term 'contemporary art' arises, what does it mean? Does it mean all the work made by all the artists living and working at this moment? Does it mean only what is 'of its time', if so who then decides what art that is. Certainly there is a sense that Nicholas Serrota, director of Tate Modern, and the collector Charles Saatchi (who has just opened a new gallery of his own collection close to Serrota's fiefdom) have together foisted their version, their choice of art and artists onto this particular 'time'. Whether or not future art historians will see beyond this narrow interpretation of late twentieth, early twenty-first century 'British' art is a moot point. We might argue this was London art, we might argue that in a book of essays on contemporary art in Wales it doesn't concern us. On the contrary, the established consensus of

fashionable art hits the production of art in Wales as much as any-where. Judgement by gallery curators and administrators of the art complex in Wales are equally in thrall to the perceived notions of quality that filter across. I consciously avoid saying, 'filter down'.

The selection of artists for Wales' first independent appearance at the Venice Biennale illustrates this prevailing condition whilst reinforcing the idea we have of being somewhat at the lower end of an uneven playing field. We are often accused of being provincial, and when given the opportunity to define ourselves, by ourselves, we seem to be in full agreement. The artists selected are not the problem; it is the absence of one crucial factor within the party that purports to represents Wales that irks. Not one artist who might be thought of as part of the community of artists operating in Wales itself, consistently exhibiting and contributing, was deemed appropriate material for this little outing. Two of the artists, Bethan Huws and Cerith Wyn Evans were born in Wales but have worked away for many years. Though it has been argued that the work of the former, now living in Paris, is relevant in Welsh cultural terms, I don't think that is why she was chosen. The film *Ion On* that will be shown in Venice is preoccupied with the persona of The Artist and that person's relationship to dealers and curators, in one sense a universal theme (if you're an artist) but perhaps a self-indulgent one if you are not.

Cerith Wyn Evans is also selected to exhibit at the Biennale's centre as part of a group exhibition called 'Utopia Station'. His work for the Wales exhibition will 'speak' to its partner across the city. The other two artists, Paul Seawright and Simon Pope have come to Wales to work in recent years. Seawright, who is currently Head of Photographic Research at the University of Wales College, Newport, is known for images of his native Belfast that employed an effective allusive approach to convey the emptiness and desolation caused by the sectarian strife. A recent Imperial War Museum commission to visit Afghanistan has resulted in a new series of images depicting the post-war zone, bombed buildings and emptiness caused by the prevalence of invisible mines and unexploded ordnance. Pope is to create an artwork during

the course of a residency in The Green Shed, a laboratory for art in the grounds of the Wales Pavilion.

There is no doubting the pedigree of these artists, and this selection can't be faulted for its recognition of the valuable input made to Wales' own 'art world' by incomers, nor for celebrating 'outgoing' artists from Wales who have achieved success in an international arena. But why is there not one artist on the list to represents the growing tendency of indigenous artists to stay in Wales or to return home to pursue a career, and incidentally, in so doing, to enrich the art scene and assist its growth? Curatorialy this selection has been conformist to a degree that allows no reflection of Wales as a vibrant artistic community in itself. It reflects only this; Welsh artists (still) leave Wales to get on and we only recognize them when they have made it elsewhere, when they become, in effect, 'celebrities'.

This critique is not based (as it will surely be accused of) on nostalgia or nationalism. It is about groupings, power structures, the nature of the process of selection and the grounds on which they are made. Obviously this has repercussions for art, and for the notions of quality that are used to defend choices. Naturally the selectors don't want to face the opprobrium of their colleagues on the international circuit. They tend therefore towards the safe bet, ignoring the fact that the most interesting shows at Venice and elsewhere come from places where they don't care about the pleasantries, or have any fear of rejection.

Pre-emptive strikes in defence of the selection are based on the conjunction of the term 'new confidence' in proximity and in opposition to the word 'parochial'. This is of the 'we are now confident enough not to...' variety. Imagine a post-feminist viewpoint that suggests women are now confident enough to be subordinate to men. That sort of self-deceiving confidence displays the colonialist assumptions that we believed we had grown out of. Arguing that the inclusion of artists on the basis of nationality would inevitably lead to a parochial mess, as some have done, is close to the institutionalised racism that was common in discussions of Welsh 'native' culture more than a century ago.

where to show? what to show? who to show?

From a cursory analysis of this case it becomes apparent that we are haunted by this prevailing set of assumptions and attitudes, a condition that has been defined as 'culture shame'. It is a well-documented factor of cultural life, one that is by no means unique to Wales. The conditions that produce it, historical, political and cultural, have a tendency to cause internalised, institutionalised and entrenched attitudes that then perpetuate themselves, often under the guise of 'new confidence'. No longer a conspiracy, it has become a normalised procedure, one that has to be consciously identified and argued against before we can re-order our priorities.

Selection of art under these circumstances is always political. Politics are historically based. We don't start from scratch. New developments conjured from thin air cannot ignore real developments that have gone on before and concurrently. An awareness of the history of a political and cultural condition is necessary in order to combat such a situation. For example, it is assumed that had Wales been given the opportunity to exhibit in Venice fifty years ago, or twenty years ago, we would have embarrassed ourselves with a display of parochial art. I doubt that very much, not because I don't believe parochialism to be of necessity an embarrassment, nor that artists in Wales are necessarily parochial, but because we would undoubtedly have had to live with a similar selection based on the same assumptions, and also hear it proclaimed as 'new confidence' at the same time. Confidence, new, old or in between, is not boosted by being taught that the only way to succeed is to leave.

We are encouraged to believe that for artists to be selected for Venice they must have achieved that notional standard of excellence and quality. This is a notion that is set and ratified in London, a notion that we must be seen to go along with, so that we don't appear 'provincial' or 'out of touch'. Staying in Wales, as more and more artists are doing is, by this token, a career killer. Welsh artists are provincial, and that is the official Welsh line too. In academic terms, this is a classic example of a failure to work ourselves free from an internalised sense of peripheral status in

relation to a centre of power, taste and influence elsewhere. This problem and its recognition is a key issue in postcolonial cultural politics. Literary practitioners are well aware of its influence, and it is more than ten years since Peter Lord raised the issue in relation to visual art in his vigorously argued paper 'The Aesthetics of Relevance', in which he says,

> Our lack of confidence disables us from taking our own product as seriously as we take the product of other cultures, both as makers and as consumers. The visual image is an essential medium for the assertion of national identity; the denial of the aesthetics of the one is the denial of the politics of the other.[1]

It is unfortunate that in the case of Wales this view is seen as a narrow nationalistic parochialism, rather than as a critical identification of a cultural psychology brought about by years of subaltern status. Anywhere else, an understanding and engagement with such issues might well be applauded; it would be about real self-confidence, about assertiveness and being positive about our artists and ourselves. Rather than promoting a narrow and questionable 'internationalist' agenda, can we not admit that issues of national identity and their critique are politically and artistically valid subjects for discourse, perhaps never more so than today, to be constructed and deconstructed? We should be aware that to do so does not imply a reversion to provincial nationalism and parochialism, and that there is an important distinction between cultural autonomy and chauvinism. Without this acknowledgement all we have is the perpetuation of received assumptions; it is not 'confidence' that is revealed, but 'capitulation' and 'assimilation'.

The reasoned and detached defence against criticism inevitably hinges on a promise of enhanced opportunities in the years to come. But these opportunities are, again, unknown quantities. It would have been good to prove from the very start how we viewed ourselves now, instead of which we have proved only that nothing has changed in our perceptions of ourselves. Or, more worryingly, that it is not 'our' viewpoint that is being expressed at

all. The art shown in Venice shows nothing of the changes that are being wrought, by artists in the main, within Wales itself. It is clear that unless these assumptions are addressed and critiqued all other decisions made that affect art in Wales will follow the same route, since the same groups of people will be involved in making them. I hope this critique raises issues that can be brought to the table, not as polarising antagonisms, but as constructive debates in a 'Wales-Art-World' that reflects real issues.

An interesting footnote to this is that as part of a series of seminars to be held in Venice this year critics, writers and artists will respond to the view that the Biennale is sinking under the weight of old-fashioned national representation, the uncritical extension of the invitation to include 'new nations' as participants, and the use of the Biennale as an international platform for promotion and publicity. Well there you have it: soon as Wales gains entry to the exclusive club, along with other newcomers like Latvia, Turkey, Ireland and Scotland, the 'committee' says it's closing the club and moving to new premises.

But to return to the question of what is contemporary art. Surely it is a term applied to the work of challenging artists, work that is going to be new and sometimes difficult to comprehend, sometimes fun, sometimes portentous, sometimes radical and esoteric. It may often not succeed, even on its own terms. We are told that the CVA's failure was that it did not sufficiently pander to the tastes of the 'local' audience. Might that mean the boringly conservative, the paintings that strive to create a copy of the world we see, technique raised to the level of fetish? Of course, others might not agree, the chances are they vehemently disagree, and the proliferation of media and concepts adds to the confusion. The *Western Mail,* for example, judging from recent form, might have every public building in Wales festooned with the cartoons of Andrew Vicari. What is this crazy love they have for an expat inhabitant of the south of France? Oh I forgot, he's one of the richest artists in the world. He also claims to have won the Gold Medal at the National Eisteddfod whilst still a schoolboy, at a time when no such award was given. Perhaps this is the sort of

work that people really want to see ... and perhaps the *Western Mail* is the sort of paper we all want to read.

That is the problem. If you cannot please all the people all the time, it becomes obvious that some people can be pleased most of the time but by different galleries and different spaces. Whatever the exhibiting policy of a contemporary art space, it is never going to please the populace as a whole; it's a contradiction in terms. Bilbao's Guggenheim might well have surmounted that problem; the people love the building, not necessarily what goes on inside it.

In Cardiff, artist-led initiatives have often filled the gap left by the lack of a properly funded *Kunsthalle*. Chapter Arts Centre was an artists' initiative back in the 1970s when the empty shell of a school was occupied and turned into studios. The Artists' Project achieved success in the 1990s with international art events called *Site-ations* (Lle-olion), taking over empty industrial buildings to host a large number of artists from all over the world. Its international remit is still clear from events held in collaboration with other European artist-led organisations, in particular a major event in 2002 in New York. It can be said that *Locws International* which hosts bi-annual events in Swansea involving invited artists from abroad and from Wales, grew out of it.

A gallery called simply g39 has captured the contemporary imagination in the centre of Cardiff during and after the saga of the Centre for Visual Arts. It has succeeded in direct proportion to the failure of the CVA, running a programme of events and collaborations. While the CVA had seemed to be a vast undertaking of capital funding with a spiralling revenue-funding problem, with lots and lots of well-paid staff and a run of high profile and expensive openings, g39 survives mainly on the efforts of a willing workforce and a real belief in the necessity of art. Whilst this is by no means a self-funding gallery (very few contemporary art spaces can be), and whilst the general public might still avoid it *en masse* there is certainly a cross-over amongst the audience, enticed by free entrance and a non-threatening informality. In the centre of Cardiff, it provides a balancing, and pivotal

opposite to the Martin Tinney Gallery, that showcases the com-
mercially viable, and does much to create a market for art from
Wales, a truly worthwhile aim, and an absolutely necessary com-
ponent. The emphasis of g39 in contrast has been mostly on the
uncollectable; installation, photography and video, and that by
mainly emerging talent, many of them recent graduates from
Cardiff College of Art. It is this combination and juxtaposition of
exhibiting venues of which we need more. For Wales to engender
the idea of visual art, to create an audience for larger venues,
there must first be a profusion of varied galleries, both public and
private, as was the case in Dublin in the 80s.

g39, or The Contemporary Temporary Artspace as its other
name suggests, exists as an idea as much as anything. At the
moment, the idea inhabits a narrow three floor building (with
cellar recently added) in the Hayes, central Cardiff, on a corner
of one of the famous shopping arcades. It might one day move to
larger premises, or it might exist as an organisation that initiates
exhibitions in other spaces, much like the Ffotogallery, which
until its recent occupation of Turner House, Penarth, had been
without premises of its own for several years. So far g39 have col-
laborated with Chapter Arts Centre, used empty shop units,
billboards and video screens in the city centre. This is also an
example of a successful artist-led initiative to set up a space for
contemporary practice. As their website suggests

> g39 is ideally placed to act as a conduit for the introduction of
> interesting work from elsewhere in Wales and further afield. It
> provides a much-needed link in the Cardiff artscene as an inde-
> pendent intermediary space which has flexibility and a sense of
> experimentation; something that larger, more established spaces
> cannot so readily maintain.

g39 accords equality to artists in and of Wales alongside exhi-
bitions from outside. Since its inception in 1998 it has shown the
work of 103 artists, 82 of these being Welsh or Wales-based to an
audience of over 17,000 visitors. In that sense it presents a
'hybrid' model, an inclusive programme that does not make a

virtue of focussed criteria, accepting a natural equilibrium. Postcolonial experience teaches us that hybridity is a natural step along the way, g39 approaches this situation without making an issue of it, indeed it does it as if it's natural.

Anthony Shapland, artist, curator and one of those instrumental in establishing g39, was born in Pontypridd and grew up in Bargoed, a town that by then had no cinema or facilities of any kind for those inclined towards the arts. As teenagers he and his group of friends used to plan how they would revive the town, get it going again. He left the Rhymney valley for college in Southampton, spent time in London but came back, to the surprise and scepticism of many. Essentially, perhaps subconsciously, that idea to "get things going again" was still there. He realised that young artists in Cardiff, and Wales, had little opportunity to get onto the ladder of exhibiting because, while there were a few rungs half way up, there were none at all nearer the bottom. Seeing an Artists' Project event, *Borders*, in 1996 when he came back, spurred him into the long struggle to get (and keep) g39 going. He is from a younger generation, differently politicised but running with an idea, an idea that Wales is and can be inclusive, that its constituent parts are mutually beneficial, and that we can still define ourselves separately without being 'provincial'.

Shapland believes a problem for artists in Wales is that, in the last ten years, there have been no structures in place that help artists to achieve mature careers. There is a 'glass ceiling' effect even now, so an artist given exposure as an emerging talent in g39 might then get shows in other public galleries within Wales, but then that's it. It stops there. A bigger venue, more impressive, that can set up international exchanges (something g39 hopes to do) is the stage that's needed. Maybe then public confidence in our own artists would mean they would not be passed over in cases such as the Venice selection. He hopes that in the next ten years, artists now showing at g39 are not going to hit the same 'glass ceiling'.

As it is, g39 is able to take risks that a major gallery would be

very cautious of taking, and by doing so they might formulate a strategy towards the art scene in Wales that in the long term may change the assumptions that contribute to that caution.

It's a space for experimentation so maybe it can afford to do that. Let us hope it's more than that; let us hope that it shows a shift in attitude and assumption.

2.10
ON THE ISLAND OF GWALES:
A POSTCOLONIAL PARABLE

On the edge of the wasteland called Ground Zero on the island of Manhattan is a place called the Orange Bear Bar. At eleven in the morning the bar was lined with grizzled middle-aged 'hard hats', knocking back strong spirits liberally doled out by the Spanish landlady. Most had worked on constructing the twin towers in the 70s and felt honour-bound to volunteer to clear up the devastation. They were subdued, eyes distant. One of them said, "nothing's going on here, just a bit of transit work that's all", and then added, "we're all fucked up here". The construct of iron, steel, glass and concrete had come tumbling down, turned to dust. A little later, further down the road in another bar, a poet and an artist from Wales were constructing a poetic postcolonial parable, consisting solely of air.

The series of paintings and drawings 'Horizon Wales' show the geographic outline of Wales turned on its side and appearing as an island on a distant horizon. The Welsh title is 'Gwalia ar y Gorwel'. The name Gwalia stands for Wales, but also reminds us of that fabled island of Gwales which features in the story Branwen Ferch Llyr in the *Mabinogi*. This story takes place in the aftermath of a tragic and brutal war in Ireland, undertaken to rescue the Welsh princess, Branwen. She was the sister of Bran the Blessed, king of the Islands of the Mighty (Britain). At the end of a long story, seven survivors made their way to the island of Gwales bearing with them the severed head of their leader Bran. For eighty years they lived in a state of bliss, forgetting all the past and present horrors, lulled by fantastic stories that were told to them by the severed head and sung to nightly by the birds of Rhiannon. They were warned however, never to open a certain door that looked out upon Aberhenfelen. We can only imagine

what those stories might have been like. Sustaining myths that could be interpreted as great truths for the times they lived in. Like bar room stories that men indulge in to vindicate themselves and absolve themselves from their responsibilities to the past, present and future. These men were warriors, survivors of a bitter and heartbreaking sequence of events, they were 'all fucked up', they could not allow themselves to think about their losses. Were the stories they heard like films being played on the darkened screen of their minds, were they fever-induced hallucinations?

After eighty years of this wondrous existence, one man, Heilyn fab Gwyn, declared that it would be a shame on his beard if he did not open the door. He opened it, and all the collective sorrows they might have felt over all those years, memories of the war itself and the death of Branwen, realization of the perilous state of the nation and their own halted ageing process caught up with them. The head of Bran ceased to talk and had to be delivered immediately to London to be buried under the White Tower, where prophecy said, it would protect Britain from future invasion. The men attended to the task of reconstructing their nation.

Here, I shall fabricate another outcome for the story. Being Welsh (or indeed, being human), would not these men on Gwales have immediately regretted the opening of the door and would they not endeavour to shut it post haste? The force of the bad memories flooding through the door would have made it impossible for it to be shut completely but it would have stemmed the tide somewhat. Using their combined weight, let us surmise that they managed to shut it half way. Thus, the head of Bran continued to tell them half stories which were never concluded, but left in mid air. The songs sung by the birds of Rhiannon became discordant, but the men still listened to them. The head never reached London to fulfill its protective prophecy and the invasion, as we know, did happen.

This is only a story, but maybe it illustrates the problem Wales has with issues of colonialism, nationhood, identity and status. Everything is half-done, half-undone, mainly by us. That door is only half-open, or only half-shut. The natural processes have

become confused. Unlike colonised peoples 'proper', where there are distinct phases, periods of conquest, colonisation, assimilations, and reactions; nationalism, decolonisation and postcolonialism, we in Wales seem to have lived pieces of all these phases but in a jumbled-up chronology. Half of us argue that none of this happened at all since we were never a colony, for them in their certainty we were/are a province, does that mean we can become postprovincial, if there is such a thing? Our 'national awareness' has ebbed and flowed over the last two or three centuries, never reaching fulfillment. The fabrications of Iolo Morganwg, necessary in a process of "nation-building", come to mind, as do the heroic paintings of Christopher Williams, even the highly visual construction by Lady Llanover, of the 'national costume'. National institutions such as the University of Wales and the National Museum were set up with all the outward signs and intent of approximating the institutions of a State, but most seem to have capitulated from within and this is very much to do with that pathology that the writer Emyr Humphreys refers to as "culture shame". If we look at the visual arts in this light, we might wonder why a whole narrative has been elided from history until Peter Lord revealed it recently. You won't find this art story in the National Museum and Gallery of Wales. Peter Lord's three-volume opus on the visual culture of Wales is a paradigmatic step in the process of decolonisation.

On a visit to Syracuse to participate in a conference hosted by the North American Association of Welsh Cultural and Historic Studies, and following that for three days in New York, there was considerable talk around the subject of Gwales between the poets Twm Morys, Iwan Llwyd and myself. We speculated on the fact that we might still be on the Island of Gwales, and that Wales itself was always on that distant horizon just beyond our reach. Whether the half-remembered traumas of the past were inhibiting our development in the 'real world' of today, and that those half stories told to us by Bran still exerted sufficient charm to keep us in their thrall. Were we still reciting fabulous stories to ourselves to keep reality at bay? What is certain is that we saw

very little of New York. New York however must have infected our thoughts. Is it not some kind of Gwales, where refugees forget their past? An island suddenly made aware of a hostile world outside. We, in an Italian-run island in lower Manhattan, sat and discussed the colonised mentality hidden in our own inheritance.

Perhaps the elaboration of such a fractured theme seems only possible in postmodern times, but we in Wales have not attained the status of a fully postcolonial entity concomitant with those times. We have never dealt with more than half the issues at any given time. Terry Eagleton, in the closing address of the James Joyce Conference in Trieste, is reported in Ireland's *Circa* magazine as listing three paradigmatic stages through which postcolonial countries go. I quote from *Circa*:

> To paraphrase what he said, initially, one finds much in common with other countries in the same boat, tries to make sense and is obsessed with the trauma. In the second stage, one wishes to leave it all behind. History is embarrassing and one would rather concentrate on getting on with things. Only in the third stage is one really free – which means also free to revisit the issues.[1]

Which pose do we strike? We seem unsure, not wholly one nor the other, again contradictory oppositions emerge. What do visual art and its culture in contemporary Wales tell us about the state of our psychology?

One artist in particular seems to illustrate the nature of our condition. I was asked to write about Tim Davies' work for a book, *Process*[2], and in doing so began to see the dual aspects of his work: on the surface a pristine and orderly formalism; underneath an edgy political commentary. Both inhabit the work simultaneously. A world of meaning submerged, hidden under an outward guise of something else, equally interesting and more internationally acceptable perhaps, but incomplete. Only half the story.

The aim of using postcolonial theory as a tool, a discursive terminology, is to examine deeply internalized assumptions in order to surmount the problems that that condition causes. There are now pluralities where there were certainties and by that token, it

is possible for minority culture, postcolonial culture, to gain a platform. It also means that our own 'minority culture' is becoming fractured, and that there is more than one way of operating within its confines. This should not preclude those elements that might be called 'essentialist' being voiced, along with an inclusiveness of reference and appropriation.

An artist such as Tim Davies draws attention to, and considers, aspects of the cultural situation, without compromising his art. His work is not illustrative in a literal sense. He alludes to the story of the Tryweryn flooding indirectly. As well as being an aesthetically beautiful piece, 'Capel Cleyn' is a fitting memorial to the people who lost their homes and rootedness by the construction of a dam in their valley[3]. It is a floor piece made up of five thousand cast wax nails inspired by the discovery of one rusty five inch nail reclaimed from the dried up bed of the lake one rainless summer. The work can be viewed as an aesthetic exercise in minimalist, formalist mannerism; the 'true meaning' is hidden under the outward appearance of an international style, yet that is only half the story. Like Wales' culture itself, the other half needs to be exhumed in order to extrapolate meaning. To understand the work fully you need to be of the culture that it comes from or be open and willing to learn about that culture. The cumulative effect of his work is to elucidate that half-submerged culture, a culture of which visitors to Wales (or viewers of the work) can remain completely ignorant. I must stress that the work, like the landscape of Wales, can be enjoyed without that awareness, but the depth of enjoyment is increased with engagement. An understanding of these issues also relates to a wider appreciation of similar issues elsewhere, and Davies has successfully transplanted his methodology to address issues in Croatia, Belize, Estonia and Poland.

In this half-and-half existence that we have adopted, to return to the parable, it is we ourselves who have employed subterfuge to survive. Chameleon-like, we have attempted for much of our history to mimic the outward appearance of our colonising neighbours, and in such a guise we have prevailed, but with the

danger of forgetting what it is of ourselves we have hidden, and where we have hidden it.

Tim Davies, with another kind of subterfuge, forces us to re-examine those 'meanings'. He explores typical postcolonial themes in his work, the issue raised by language loss, depopulation ,inward migration and industrial decline, whilst the uses of iconography, such as the castle and Welsh lady postcards, are challenged in a new way. Davies' series of postcards, in which the cute girl in the tall hat is excised with a scalpel leaving a negative image, forces the viewer to examine the landscape in the background, and to notice, really notice and ponder upon the absent image. Absence here speaks volumes. Though invisible now, the phenomenon of the folk-costumed fabrication becomes paradoxically more visible. Are we managing to unburden ourselves of outdated stereotypes, or have we in doing so, merely created a void?

These issues are not only reflected in the obvious, surface themes of Davies' work. It is through the nature and process of the work's construction that he provides the most sophisticated critique of unreconstructed 'colonized' cultural behaviour. By not revealing the hidden depths beneath the surface calm but hinting that it is there, the artist presents the viewer with a visual and material metaphor that demands an engagement that parallels that of political decolonisation. His aim is not to pontificate, nor illustrate, but to draw us into a process of thinking that may enlighten, by demonstrating a cultural phenomenon that is easily overlooked. 'Capel Celyn' is a piece that fulfills this function.

The 'Returned Parquet' which was made for Poustina Earth Art project in Belize (1999), emphasizes the process of decolonisation as a conscious element of the artist's thinking and work. In that work, a reclaimed mahogany parquet floor from a grand house in Swansea was shipped to the rainforest of Belize, where its timber originated. The artist cleared a pathway in the forest and the block floor was re-laid along it.

> The gradual encroachment of the jungle onto the pristine parquet over time is an intrinsic element of the work, which is expected to eventually disappear in its true 'reclamation'.[4]

But once again, that is only half the story. Not all the artists in Wales by any means are concerned with issues of postcolonial identity or any other identity. Many are involved in the current naval gazing, of art about art; many are pure formalists (above such things as politics, at least in their work). Some believe that Wales is a Celtic theme park and others have a pantheistic reverence for the lie of the land. Some deem themselves pragmatists and deem others romantics. A myriad of tactics and stances are adopted in a small area and a small community. I tend to believe that the challenge for an invalid is to be interested in the nature of his complaints without becoming a hypochondriac. I may not be succeeding. It is accepted that all art, of whatever persuasion, reveals something of the culture it comes from. If we believe that art has greater depths, and is one of the ways that society uses to talk to itself, ask questions and makes sense of itself, then I believe that it is in the works of Certain Welsh Artists like Tim Davies that the key to that door on Aberhenfelen may be found, whether we choose to open it or not.

Tim Davies 'Postcard Series II' (2002)

NOTES

1.1 WHO NEEDS ARTISTS?
1 Carl Gustav Jung *On the Relation of Analytical Psychology to Poetry*
2 Dylan Thomas, Preface to *Collected Poems*
3 Alan Davie, *Towards a Philosophy of Creativity*. University of Brighton 1997
4 Raymond Williams, 'Base and Superstructure in Marxist Cultural Theory', *Problems in Materialism and Culture, Selected Essays*. Verso, 1980 pp38-39
5 Jeanette Winterson, Programme Notes *The Power Book*, National Theatre
6 Robert C. Morgan, *The End of the Art World*, Allworth Press, 1998
7 Francisco Toledo, interview with George Mead Moore in *BOMB*, Winter 2000, quoted by Catherine Lampert in a catalogue, Whitechapel Art Gallery, 2000

1.2 RE-INVENTING RE-INVENTION
1 Iwan Bala (ed) *Certain Welsh Artists*, Seren, 1999
2 'The Case of the Missing Body, a Cultural Mystery in Several Parts', Gilane Tawadros, *Global Visions. Towards a New Internationalism in Visual Arts* Kala Press, 1994

1.3 DEEP MEMORY, SHALLOW MEMORY
1 Simon Schama *Landscape and Memory*, Harper Collins, 1995
2 M. Wynn Thomas *Emyr Humphreys: Conversations and Reflections*, UWP 2002, p11
3 Ibid, p8
4 Ibid, p8
5 Eve Ropek (ed) *The Colour of Saying*, Gomer/Aberystwyth Art Centre, 2001
6 Geoffrey Olsen, *The Extramural Series*

1.4 THE TRAUMA OF TRYWERYN
1 Pierre Nora (ed) *Realms of Memory; Rethinking the French Past*, Columbia University Press, 1996
2 Quoted in P. Beresford Ellis *Wales: A Nation Again*, Tandem Books, 1968 p128
2 Einion Thomas *Capel Celyn; 10 Mlynedd o Chwalfa 1955-65*, Barddas, 1997

1.5 CONTINUING PRESENCES
1 Gerallt Lloyd Owen, 'Cilmeri' *Cilmeri a Cherddi Eraill* Gwasg Gwynedd, 1991
2 Miroslaw Balka, interviewed by Iwona Blazwick, Amsterdam 12 September 1990, *Possible Worlds Sculpture from Europe*
3 Mike Tooby *A Propos Ceri Richards* referring to work made in response to Ceri Richards for *A Propos* Exhibition Catalogue NMGW, 2002
4 Mel Gooding, *Ceri Richards* Cameron & Hollis 2002 pp80-81
5 John Meirion Morris, *Y Weldigaeth Geltaidd* Y Lolfa, 2002
6 See chapter 10 for a version of this story

1.7 IVOR DAVIES: A SHORT LECTURE
1 Ivor Davies *L'Eta della Avanguardie* UTET Turin 2002
2 'Displaced Memories', *Certain Welsh Artists*, Seren, 1999
3 Meic Stephens (ed) *The New Companion to the Literature of Wales*, UWP, 1998

1.8 THE CASE OF BILBAO
1 Mark Kurlanski *The Basque History of the World*, Jonathan Cape, 1999 p 335-341

notes

2.1 NOT THE STILLNESS
1 From Tony Curtis, *Welsh Artists Talking*, Seren, 2000
2 'Sea Changes', Peter Wakelin from *Not the Stillness* exhibition catalogue, Newport Museum and Art Gallery
3 Herbert Williams *John Cowper Powys*, Seren, 1997
4 Thomas McEvilley *The Exile Returns, Towards a Redefinition of Painting for the Post Modern Era*, Cambridge University Press, 1993

2.2 CROSSOVER STATES
1 *Superstructures* 1999, Centre for Visual Arts. Interview with Catherine Baum.
2 *Darllen Delweddau* Gwasg Carreg Gwalch, 2000. An exhibition preceding the launch of the book at the National Eisteddfod of Wales, Llanelli. The book features work by Angharad Pearce Jones and David Hastie, and twenty-four other artists
3 Eric Rowan *Art in Wales*, UWP 1985

2.5 JOHN SELWAY, PAINTER
1 André Malraux *Picasso's Mask*, Da Capo Press 1994, p98-99
2 Dialogue between Fabian Marcaccio and Jessica Stockholder, quoted by Simon Wallis in the catalogue introduction of *hybrids*, Tate Liverpool, 2001
3 Roger Scruton *The West and the Rest* Continuum, 2002 p68
4 *Days Like These* Tate Triennial of Contemporary British Art 2003

2.7 ART AS CATHARSIS
1 *Concise Oxford Dictionary* definition
2 Karen Ingham *Death's Witness*, Ffotogallery Wales 2000
3 'Uncanny Tomb of Memory', Karen Ingham. *Death's Witness*
4 Suzi Gablik *The Re-enchantment of Art*, Thames & Hudson, 1991
5 André Stitt *Second Skin (Behind the Mask)* Tokyo 1st of March 1996. Published in *homework*, Krashverlag, Köln, 2000
6 C.G. Jung *On the Psychology of the Trickster Figure*

7 Paul Virilio *Art and Fear*, trans. Julie Rose, Continuum 2003

2.8 WHAT'S HE BUILDING IN THERE?
1 Marc Guillame, in *Zone* 1/2 (1986) p439
2 Brenda Chamberlain, *Tide-race* 1962

2.9 WHERE TO SHOW? WHAT TO SHOW? WHO TO SHOW?
1 Peter Lord *The Aesthetics of Relevance*, Gomer, 1992 p8

2.10 ON THE ISLAND OF GWALES
1 Documenta 11 Christa-Maria Lerm Hayes. *Circa* 101 Autumn 2002, p70
2 *Process: Explorations of the Work of Tim Davies*, Seren, 2002
3 See 'The Trauma of Tryweryn' essay in the first section of this book
4 *Made in Belize*, catalogue, Tim Davies & Adrian Barron, 2002

ACKNOWLEDGEMENTS

It was with some trepidation that I asked Mel Gooding to read my rough essays with a view to providing the Foreword for this collection. I was pleased and vastly relieved when he agreed to write it, bringing an insightful appraisal of my aims, and a poetic turn of phrase to the proceedings. I am indebted to him for his generosity and greatly honoured by his involvement.

I extend my gratitude to John Barnie for publishing my writing in *Planet* over the last five years, and allowing some of this to be reprinted. Thanks to Mick Felton and Simon Hicks at Seren for editing, designing and patiently waiting, and not only for publishing this collection, but also for their commitment to a host of other, much needed volumes on art in Wales. For me, the encouragement of writers has been essential for my continuing effort at writing, and Professor Tony Curtis warrants particular thanks, along with Jane Aaron at the University of Glamorgan. I should not forget the many friends and colleagues with whom conversation is a constant contribution to the formation of ideas and understanding, which sooner or later turn into sentences or paragraphs of text. Tamara Krikorian, Tim Davies, Sue Williams, John Meirion Morris, Igone Orbe (Bilbao), Hugh Adams, Kim Waal (Syracuse), Richard Gwyn, Michelle Ryan, Iwan Llwyd, Twm Morys are only a few of these...

My thanks go to all the artists who were willing to submit their art and lives to my questions and interpretations, and for permitting the reproduction of their work.

My final thanks go to the person most affected by my writing efforts, my wife Sophie, to whom I dedicate this book.

INDEX

index

index

index

index

AUTHOR NOTE

Artist and writer, Iwan Bala was born in north Wales in 1956, and has lived in Cardiff since 1974. In 1990 he was artist in residence at the National Gallery of Zimbabwe in Harare. He completed an M.A. in Fine Arts at the University of Wales Institute, Cardiff in 1993, has been awarded the Gold Medal for Fine Art at the National Eisteddfod, and in 1998 was presented with the Owain Glyndwr Medal for contribution to the arts in Wales. He has exhibited widely in Wales and outside, including at The National Gallery of Zimbabwe; The Rotunda Gallery, Hong Kong; The Artists' Museum, Lodz; The Museum of Modern Art, Zagreb; The Riverside Studios, London; the Bank of Ireland Exhibition Centre, Dublin; The Tramway, Glasgow, and the Claude André Gallery, Brussels.

Bala's work is held in numerous public and private collections in the UK and abroad. He is a member of Beca, Ysbryd/Spirit, a founder member of The Artists' Project and vice-chairman of the National Eisteddfod of Wales Arts and Crafts Committee. His writing has appeared in *Planet*, *Barn*, *Golwg* and the *New Welsh Review*. *Here + Now* is his fourth book on contemporary art in Wales.

He is currently Projects Manager with Cywaith Cymru . Artwork Wales, the national organization for Public Art in Wales. He is married with three children.

Iwan Bala by David Hurn

books on art from seren

Offerings + Reinventions Iwan Bala
In forthright style, Bala traces his artistic development and marks the crucial international influences on his work. Inventive, poetic, politicised, his position as one of the most radical artists working in Wales is confirmed, with assessments by Shelagh Hourahane and Michael Tooby.
Colour + b/w pbk £9.95

Process Tim Davies
Davies' work has an abstract, formal beauty, yet explores issues of fundamental importance. Intervention and method are at the centre of his art; process is its determining feature. Contributions from David Alston, Iwan Bala, Susan Daniel-Mcelroy, Anne Price-Owen and Davies himself.
Colour + b/w pbk £9.95

Imaging Wales Hugh Adams
A richly-illustrated insight into the visual arts in Wales. Critic Hugh Adams sets out the historical and cultural context, and, looking at painting, sculpture, installation, photography, mixed media, performance and video, celebrates the diversity of contemporary art here. Among more than forty artists featured are David Nash, Shani Rhys James, André Stitt, Tim Davies, Sue Williams, Peter Finnemore, Cerith Wyn Evans and Paul Seawright.
Colour pbk £9.95

Haha: Margam Revisited
Karen Ingham and Hugh Adams
Eight contemporary photographers revisit Margam, birthplace of the medium, exploring the changing social history of both town and estate, while art critic Hugh Adams returns to the scene of his childhood to discuss its artistic and social heritage.
Colour + b/w pbk £9.95

Certain Welsh Artists Iwan Bala (ed)
With contributions from Wales's leading artists and theorists, this collection of personal statements and critical essays, written in response to the concept of custodial aesthetics, reveals the vibrancy of contemporary Welsh art.
Colour + b/w hbk £19.95

Welsh Artists Talking Tony Curtis
Illuminating interviews with ten artists, among them the late Alfred Janes, Ivor Davies, David Garner, Brendan Stuart Burns, Lois Williams and David Nash.
Colour + b/w hbk £19.95

David Jones: The Maker Unmade
Jonathan Miles and Derek Shiel
This magnificent study of the greatest painter-poet since Blake considers all aspects of David Jones in the light of his experiences as a soldier, his Catholicism, and his Classical and Celtic researches. "The full record of the visual work, generously illustrated and essential on chronology." – Fiona MacCarthy, *The Observer*
Colour + b/w hbk £39.95

Arthur Giardelli Derek Shiel
Arthur Giardelli is a relief-maker of European stature who uses shells, corks and wood beach-combed close to his Pembrokeshire home to produce stunning works of art. With fellow artist Derek Shiel, he discusses his life and work. Colour + b/w hbk £30.00

Related Twilights Josef Herman
Herman's Polish-Jewish childhood, his flight across Europe to Ystradgynlais and his celebrated paintings of miners. Plus sojourns in Burgundy, Mexico, Amsterdam, New York, and pen-portraits of artists including Millet, Courbet, Epstein, Klee and Derain.
Colour + b/w hbk £19.95